MAIDENHEAD

THROUGH TIME

Elias Kupfermann
& Carol Dixon-Smith

AMBERLEY PUBLISHING

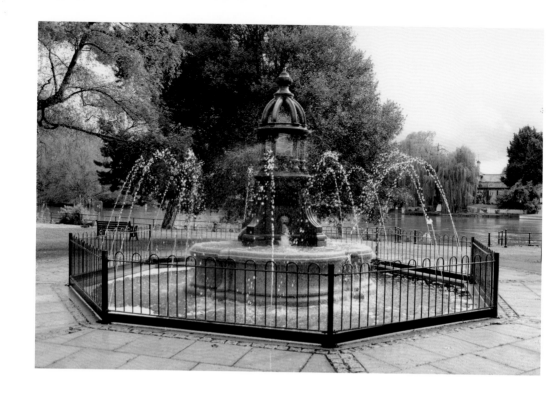

To Tony, Rebecca and Sarah with love.

'Just do it'

First published 2014

Amberley Publishing
The Hill, Stroud,
Gloucestershire, GL5 4EP
www.amberley-books.com

Copyright © Elias Kupfermann and
Carol Dixon-Smith, 2014

The right of Elias Kupfermann and Carol Dixon-
Smith to be identified as the Authors of this
work has been asserted in accordance with the
Copyrights, Designs and Patents Act 1988.

ISBN 978 1 4456 3849 2 (print)
ISBN 978 1 4456 3853 9 (ebook)

British Library Cataloguing in Publication Data.
A catalogue record for this book is available from
the British Library.

Typesetting by Amberley Publishing.
Printed in the UK.

Introduction

The site of the present town of Maidenhead has been in existence since the thirteenth century. Before that time, there was settlement at North Town with Saxon origins, known as Elentone, which is mentioned in the Domesday Book. In the 1960s, archaeological excavations revealed the site of the Domesday manor.

Maidenhead most probably gets its name from the large hill, or the ancient Celtic 'mai-dun', on the Taplow side of the River Thames, which has been continuously occupied since prehistoric times. The establishment of a wharf or 'hythe' on the opposite side of the Thames led to the creation of the riverside town. As the town grew, a timber bridge was constructed around 1280 to cater for demand from the thriving market. The old timber bridge was repaired several times in its history, before being totally demolished, and the current stone bridge was erected by Sir Robert Taylor in 1777.

Due to the area around the Thames being quite marshy and subject to frequent flooding, the town of Maidenhead was established on a little inland of the river on slightly raised gravel islands separated by intermittent streams, such as at Chapel Arches and Moor Arches. A timber bridge has existed across Chapel Arches since at least 1380, where it is mentioned in a chronicle written by a French monk from St Denys.

In 1270, a chapel of ease was erected between the parishes of Cookham and Bray that stood in the middle of the street. It was erected by a member of the Hosebund family with much protestation from both the Cookham and Bray vicars. A chaplain's house was also erected, adjacent to the chapel, using oak from the Forest of Windsor. By 1315, the vicar of Cookham, with the consent of the vicar of Bray, was allowed to appoint a priest to officiate in the chapel chantry. The chapel was rebuilt twice, once in 1724 and again in 1824, as it was now too small for the growing town. This church was set back from

the High Street, and a new priest's house was erected adjacent to it, but this was pulled down in 1967 and the present St Mary's church built on its site.

From the medieval period onwards, inns started to appear on what was to become the important highway of the Bath Road. These included the Bull (1459), the Bear (1489), the White Horse (1574), the Saracen's Head (1680), the Sun Inn (late seventeenth century) and the Folly Inn on Castle Hill (1820). They brought large numbers of people to the town, which became very prosperous between the seventeenth and nineteenth centuries. The demise of the coaching inn was due in part to the coming of the railways to the Maidenhead area from the 1830s onwards.

The town's first train station was originally in Taplow, just off the Bath Road, close to the river. Until 1839, the station acted as the terminus for the Great Western Railway.. In 1838, Isambard Kingdom Brunel's great railway bridge had been constructed across the Thames, but was not used until the following year. The bridge linked up two stretches of track either side of the river and, by 1840, the railway had reached Reading. In 1854, the Wycombe Railway Co. built a line from High Wycombe to Maidenhead with a station at Castle Hill known originally as 'Maidenhead' (Wycombe Branch), but was later renamed 'Maidenhead Boyne Hill'. Blocked-up entrances to the station can still be seen as one ascends Castle Hill. The current Maidenhead station was not built until 1870, and was originally called 'Maidenhead Junction'. It eventually replaced Boyn Hill station as well as the original station at Taplow.

The coming of the railways brought many people to the town, and a large number of shops started to appear in the High Street to cater for all needs. By the late nineteenth century, Maidenhead had five breweries, the largest being Nicholson's Brewery. This led to a great many public houses appearing on the High Street and towards the river, from the 1830s until the early twentieth century.

During the late Victorian and early Edwardian periods, Maidenhead's riverside became a fashionable resort with a large number of hotels and institutions opening, such as Skindles, the Riviera Hotel, Murrays Club, the Thames Hotel, the Guards Club, and the Showboat. Maidenhead riverside was *the* place to be seen and, in the 1950s, Maidenhead was known as the 'Jewel of the Thames', but this was not to last. Much of the character of the town has been lost since the 1960s.

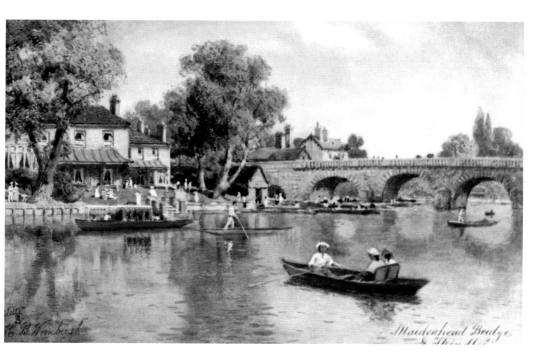

Maidenhead Bridge and the Old Brigade of Guards Club, 1891
Maidenhead's first bridge was built around 1280. The bridge was of wooden construction and was located slightly south of the present-day bridge. It was maintained by a religious group known as the Guild of St Andrew and St Mary Magdalene and, from the early fifteenth century, a hermitage chapel was established on the bridge. The hermit was known as Robert Ludlow who collected alms from people passing over the bridge for both his maintenance and on behalf of the guild. The town council is the modern equivalent of the guild.

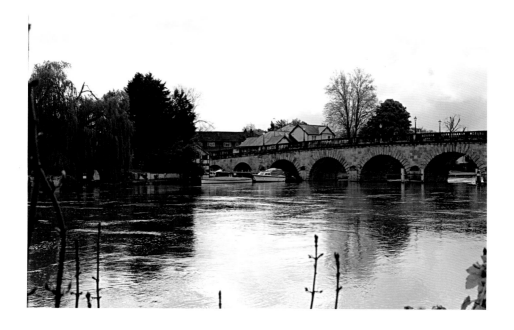

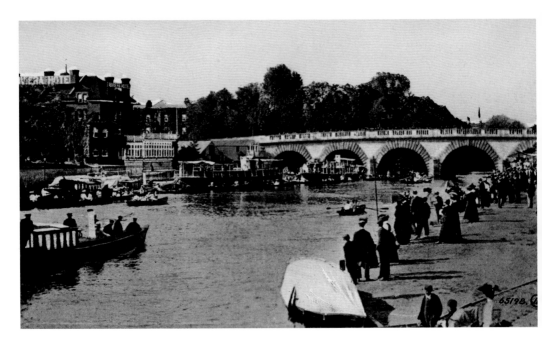

Maidenhead Bridge and the Riviera Hotel from Bond's Boathouse, 1910
By the middle of the eighteenth century, the bridge was falling into disrepair despite attempts
by the guild to patch it up. The last repair to the bridge was in 1750. In 1771, it was felt that
the old bridge had to be dismantled and the Corporation of Maidenhead applied to Parliament
to build a new bridge. The bridge was designed by the architect Sir Robert Taylor, and built in
stone by John Townsend of Oxford for £19,000. The bridge opened for traffic on 22 August 1777.
Traffic still passes over the bridge to this day.

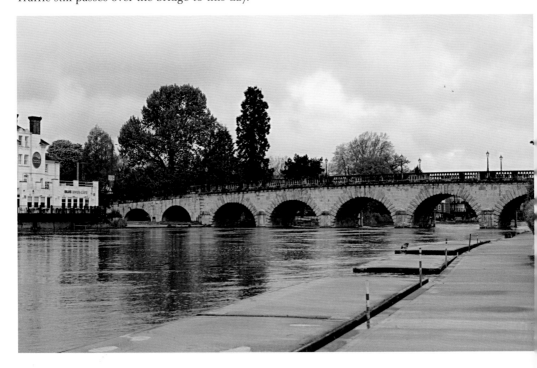

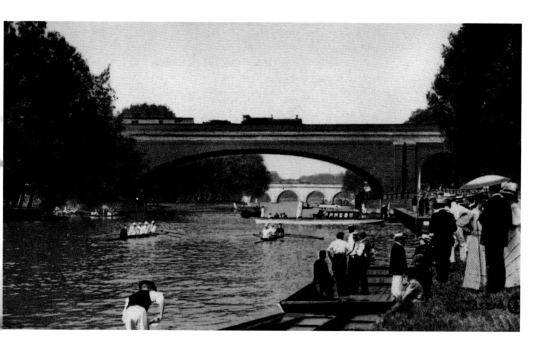

The 'Sounding Arch' and Maidenhead Bridge, 1910

The 1830s saw the beginning of the construction of the Great Western Railway that would permanently change the way people travelled across South Eastern England. Prior to 1839, the railway only ran from Paddington to Taplow, which acted as a terminus. Track had also been laid on the opposite side of the River Thames at Maidenhead. The bridging of the railway at Maidenhead was one of Brunel's greatest challenges, and possibly one of the greatest feats of world engineering. The bridge that Brunel designed and constructed was opened on 1 July 1839, and was built entirely from brick.

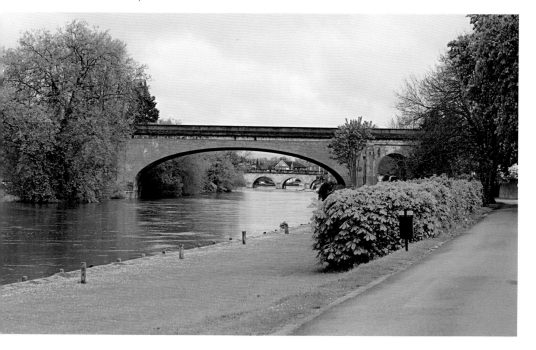

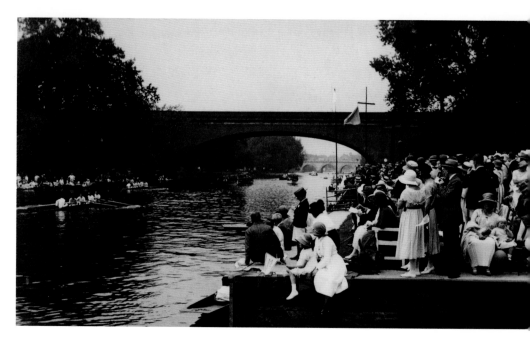

Maidenhead Regatta, 1922

The Maidenhead Regatta has been held annually since 1893 on the Thames between Bray Reach and the 'Sounding Arch'. The Maidenhead Rowing Club was founded in 1876. The club's first captain was William Grenfell, later Lord Desborough of Taplow Court. The rowing club originally had its headquarters next to the Riviera Hotel. The club moved to a new building across the river on the old Bond's Boathouse site in 1998, and was opened by Olympian Sir Steve Redgrave.

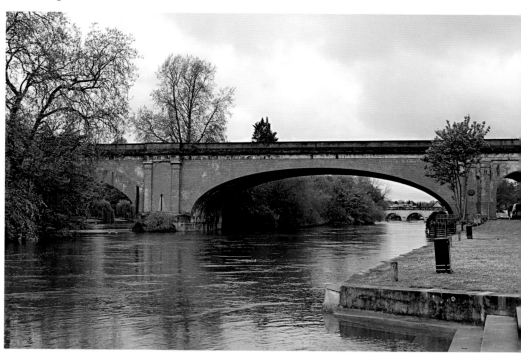

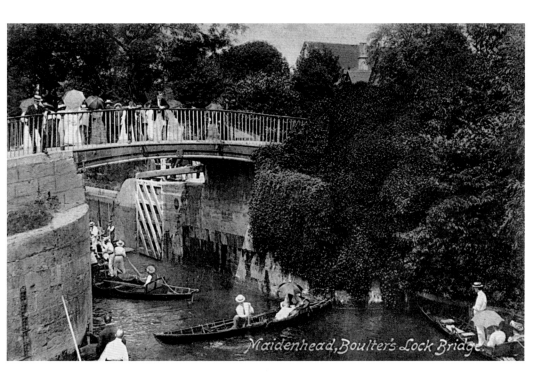

Boulter's Lock, 1905

The Thames Navigation Commission first built Boulter's Lock in 1772. Towards the end of the eighteenth century, the lock was reported to be in disrepair. A new lock was opened in 1828, known as Ray Mill Pound. The spoil from the lock cut was used to create the present-day Boulter's Island.

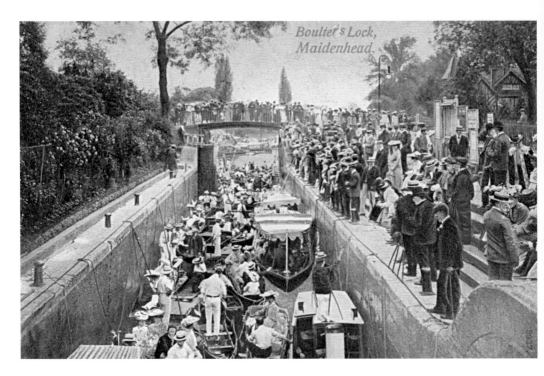

Crowds at Boulter's Lock, 1906

During the late nineteenth and early twentieth centuries, boating parties along the Thames near Maidenhead became extremely popular. This was due to the many riverside pubs and hotels that had started to spring up around the Thames at Maidenhead. The lock in particular was a popular place for the rich and famous to visit on the Sunday after Royal Ascot. In 1909, the Thames Conservancy purchased the adjacent Ray Mill Island in order to expand the lock, which was rebuilt to its present-day form in 1912.

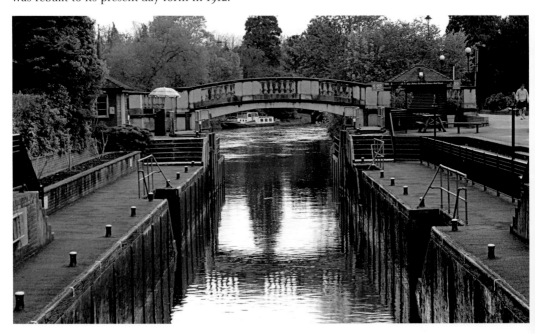

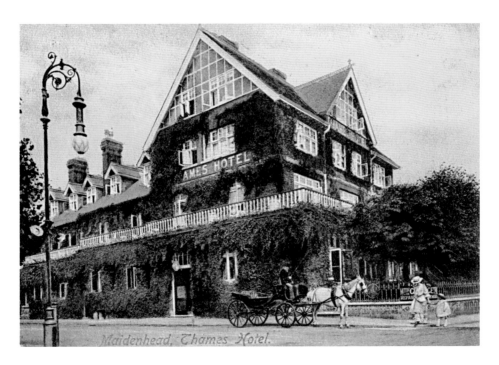

Thames Hotel, 1910

The Thames Hotel was constructed by boatbuilder and motor engineer, Henry Woodhouse and his ex-brother-in-law, William Deacon, in 1886. The hotel boasted forty-one rooms, some of which overlooked the Thames. Prior to building the hotel, Henry Woodhouse had a thriving boatbuilding business in Bridge Road. His partner William Deacon also owned the nearby Ray Mead Hotel and the East Arms at Hurley. The Thames Hotel still thrives to this day, and caters for the many visitors who come to this popular riverside area.

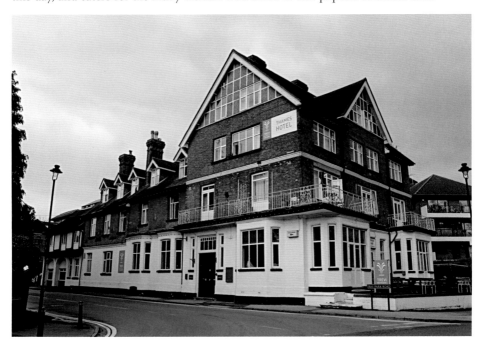

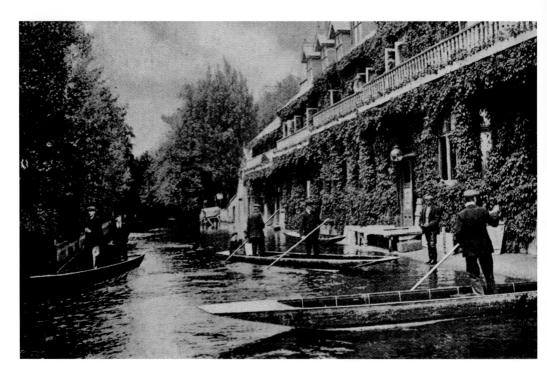

The Thames Hotel and Ray Park Road in Flood, 1907

During November and December of 1907, heavy rain led to serious flooding when the river rose by 8 inches. The water was 1 foot deep in places. Punts were used to navigate the riverside areas of Ray Park Road, as you can see. Due to the frequent flooding over the past decade, Maidenhead became known as the 'Berkshire Venice'.

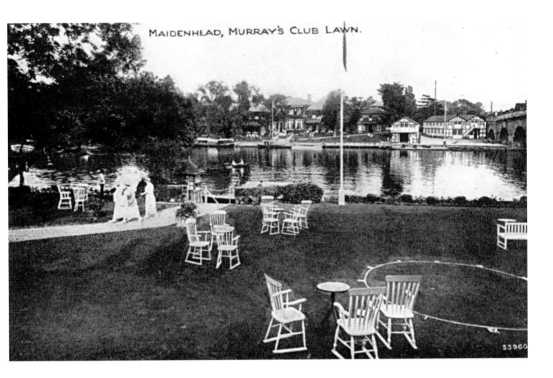

Murray's Club Lawn, 1915

Murray's Club stood on the opposite bank of the fashionable Skindles Hotel. The club opened in London in 1913, and moved to the Georgian Bridge House in Maidenhead in 1914. It became a meeting place for the rich and famous. During the summer sultry evenings, the gardens were lit by lanterns. The centrepiece of the gardens was an under-lit glass dance floor where revellers could dance the night away. A petrol station now marks the site of the clubhouse, and its former lawns are now an open space known as Bridge Gardens.

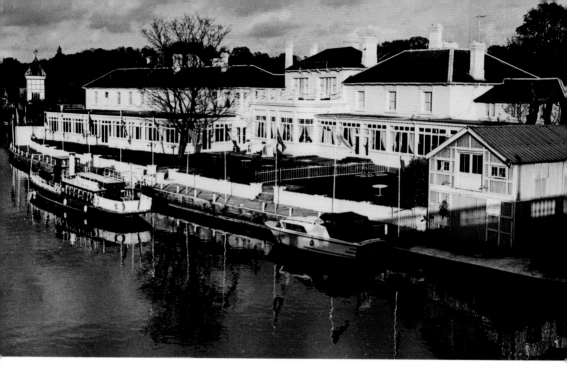

Skindles Hotel from Maidenhead Bridge, 1972
Skindles Hotel looks very sorry for itself today. In its heyday, it was *the* place to be seen and was patronised by royalty. King Edward VII was a frequent visitor, and dined on mutton chops and brandy and soda. The hotel, originally known as the Orkney Arms, was opened by William Skindle in 1833. He turned the coaching inn into a riverside hotel, which was particularly fashionable in the 1950s and '60s, and was a nightclub in the 1970s and '80s. Skindles closed down in 1995 and has been left to deteriorate.

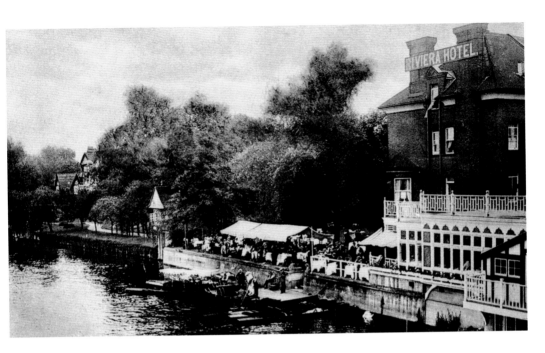

Riviera Hotel from Maidenhead Bridge, 1905
The Riviera Hotel was originally built as a private mansion in 1886, but was later converted into a hotel in 1888. This work included the extension of the east side of the building to accommodate a large dining room that over looked the River Thames. This was carried out by local builders Silver & Sons. The hotel went through a number of owners with periodic improvements being made. In 1960, it was purchased by Louis Strauss and was totally renovated. Strauss remained there until 1979 when it was sold to its present owners, Galleon Taverns Ltd.

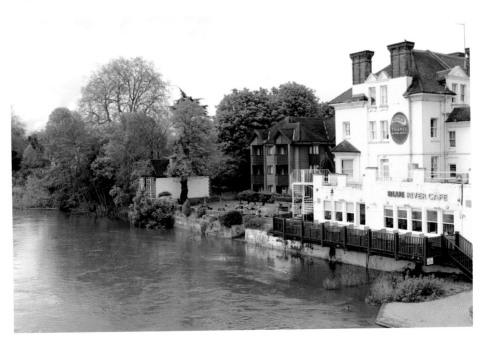

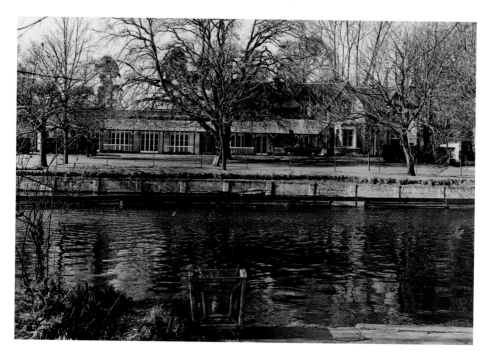

Brigade of Guards Club, 1950

In 1865, the officers of the Brigade of Guards started a summer riverside boating club in Maidenhead. The first clubhouse was on Mill Lane, Taplow (*see image on p. 8*) within the buildings later occupied by Skindles Hotel. In 1904, the club moved to the Maidenhead bank of the Thames. Two adjoining houses known as 'Riverside' and 'Eskdale' were converted into the clubhouse. During the Second World War, the ballroom became offices for the Forestry Commission, and temporary membership was extended to ATA ferry pilots based at nearby White Waltham. The club stared to decline after the war, and closed in 1965.

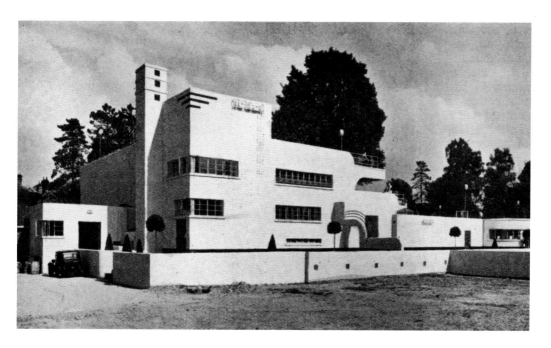

The Showboat, Oldfield Road, 1933

The Art Deco 'Showboat' roadhouse and club was built between 1932–33 by E. Norman Bailey and D. C. Wadhwa for the sum of £21,000. Built to resemble an ocean liner, the club boasted decks in the form of terraces and had an open-air swimming pool. On the ground floor was a large ballroom where dances were held. At the outbreak of the Second World War, the club reopened as the 'All Services Club'. This was short-lived, as during the early 1940s it was converted into a factory that manufactured spitfire wings. Later, the factory was used to make buttons.

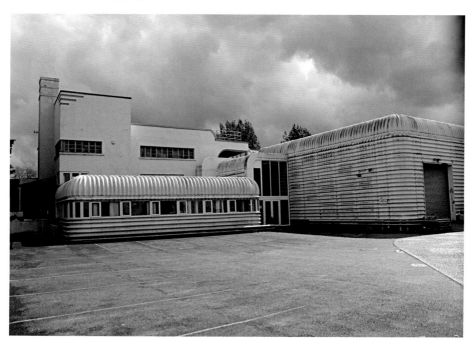

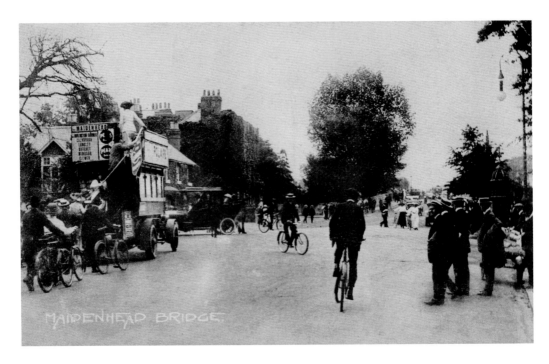

The Approach to Maidenhead Bridge, 1910

The approach to Maidenhead Bridge was always a very busy area with both travellers and partygoers alike. The large house on the left in the background is Bridge House, the home of 'turf magnate' and town benefactor, George Herring . This later became Murray's Club. On the right is Ada Lewis Memorial Fountain, which was erected in 1908. The fountain has been moved a number of times, and in 2010 it was re-situated in Bridge Gardens.

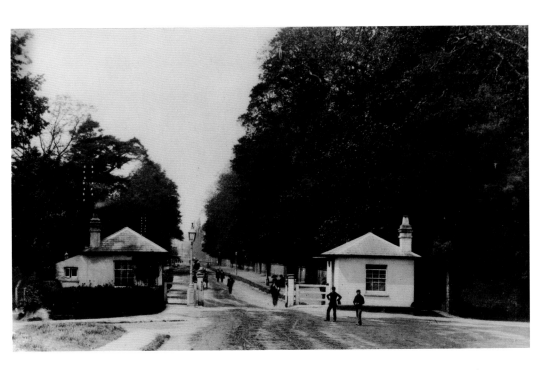

Maidenhead Tollgate, 1900

Tolls to cross Maidenhead Bridge have been collected since medieval times. In 1337, the toll for a loaded barge to pass under or a loaded cart to pass over was 1 *d*. By the 1830s, the bridge was recorded as raising £1,245 per annum in tolls. Tolls were collected at Maidenhead Bridge until 1903. The toll gates were removed on 1 November 1903 and thrown into the River Thames.

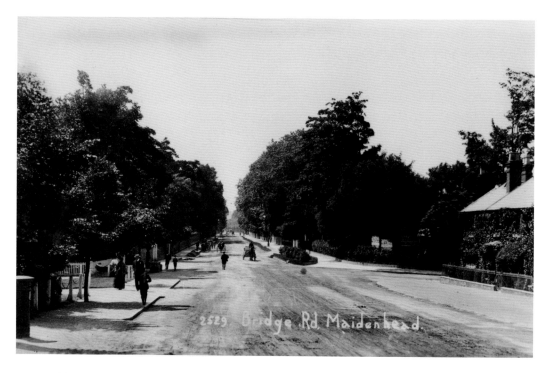

Bridge Road, Maidenhead, 1915

Bridge Road was the main road from Maidenhead to London. Large houses near the bridge were built from the mid-eighteenth century onwards, such as Oldfield Lodge and Bridgewater Lodge, while further down was Ray Lodge, another large eighteenth-century mansion belonging to the Pocock, and later, the Lascelles families. The signs on the right-hand side of the photograph show land being sold off from the Ray Lodge Estate.

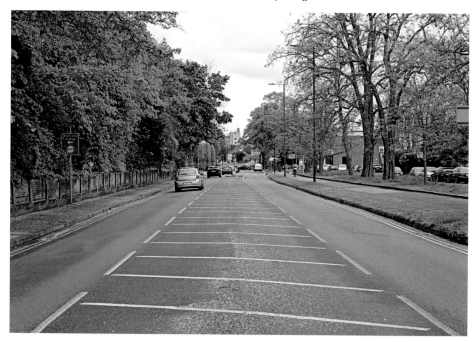

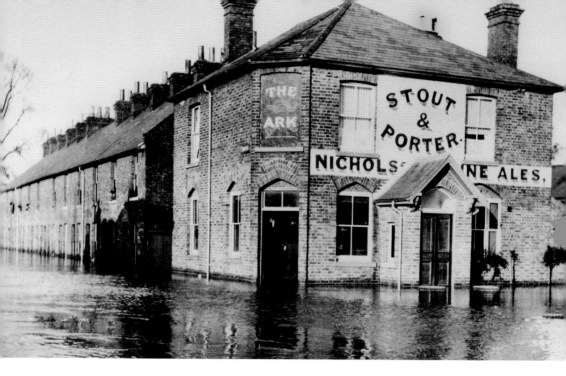

The Ark Public House, Ray Street, 1947

The Ark Public House, built in 1882, lies on low ground on the Thames floodplain. This has led to the pub flooding a number of times, especially during the floods of 1897 and 1947. When the street and the surrounding area flooded, the only way of accessing the pub and the surrounding buildings was by punt or rowing boat. The Ark was run by three generations of the Deadman family for over fifty years between 1880 and 1930. The pub continues to serve the community to this day.

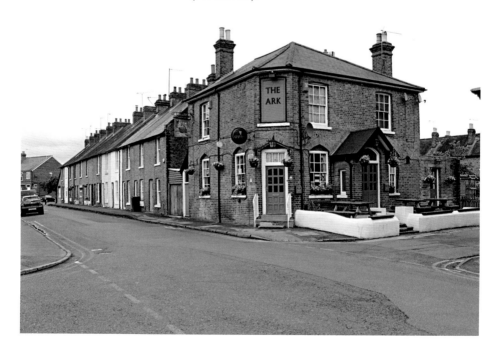

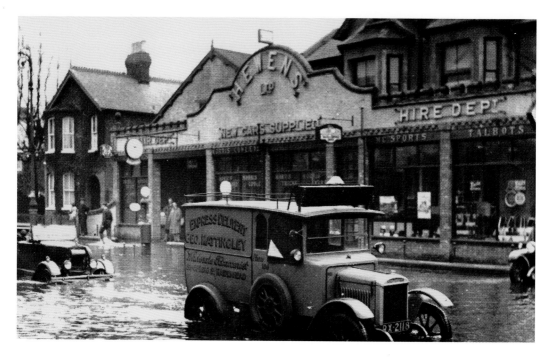

Early Floods on Bridge Road, 1925

Bridge Road flooded in 1925 and must have been a challenge to early motorists. Two cars can be seen passing Hewen's Garage, which was formerly the workshop of motor and boatbuilder, Henry Woodhouse, later proprietor of the Thames Hotel. During the floods of 1947, the ground floors of the adjacent houses were completely flooded. Hewen's Garage stood on the same site until the 1980s. The site of the garage has now been redeveloped with a block of flats.

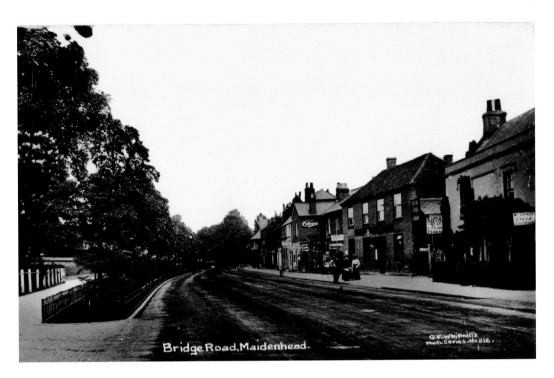

Bridge Road – Green Dragon to the Reform Public House, 1906

From the late eighteenth century onwards, a ribbon development of houses started to appear along Bridge Road. In contrast to the fashionable river end of Bridge Road, shops, beer houses and lodging houses started to operate as a continuation to the town's High Street. This view shows William Gracie's Cyclist's Rest, which served dinners and teas to passing cyclists, and the Green Dragon public house. At the end of a parade of miscellaneous shops was The Reform public house, first recorded in 1847.

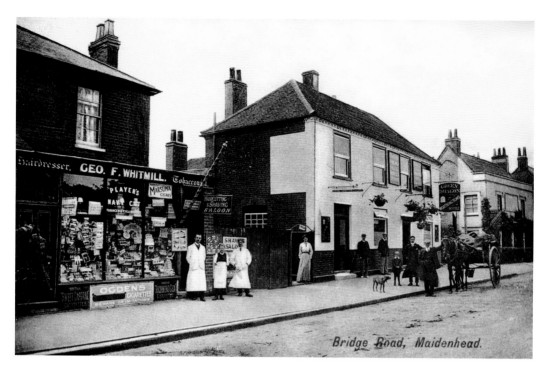

The Green Dragon and Whitmill's Hairdressers and Tobacconists, Bridge Street, 1912
The Green Dragon public house is first mentioned in a trade directory of 1796, where it was being run by Step Taylor. The building remained a public house right up until the 1990s. It housed the Maidenhead Heritage Centre for a short period of time and is now converted into offices. Adjacent to the Green Dragon was George Whitmill's hairdressers and tobacconists. Outside the shop, a very distinctive barber's pole can be seen. George Whitmill and his staff can be seen outside the shop.

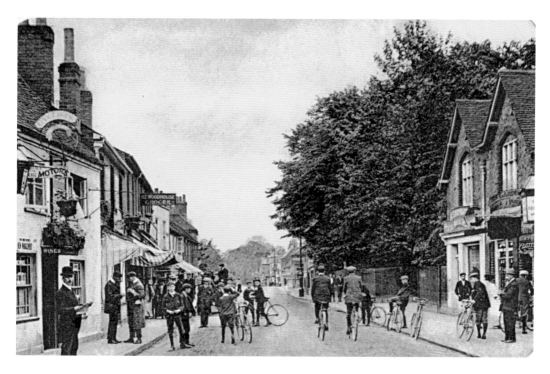

Bridge Street Looking North to Moor Arches, 1913

The entrance to the Gardener's Arms public house can be seen on the left of the photograph. The Gardener's Arms is regarded as Maidenhead's oldest building, dating from around 1607. In the late eighteenth century, the pub was known as the Three Jolly Gardeners. The area of greenery marks the entrance to an early nineteenth-century house known as The Cedars. During the 1920s, the grounds of The Cedars were used as a bus depot by the Thames Valley Traction Co. and remained a bus depot until the 1980s. This part of Bridge Street has been renamed Moorbridge Road.

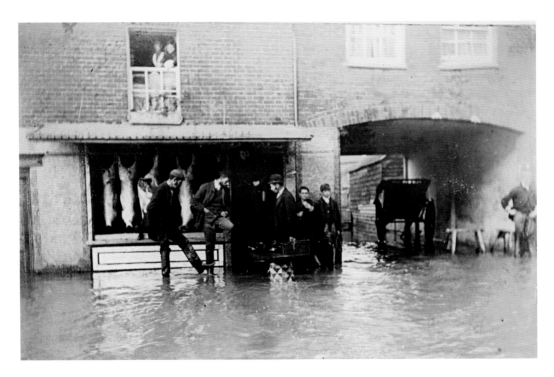

Hine's Butchers, Bridge Street in Flood, 1925

Hine's butchers was established in 1855 by Thomas Hine, a farmer from Watlington in Oxfordshire. Hine was known as 'Holy Joe' as he was a staunch Methodist and teetotaller. In 1884, local residents were shocked to hear that Mr Hine was gored by a heifer while he was driving cattle back from Reading Market. He fractured his spine, and was dead within a few days. The shop was run by four generations of the Hine family. The business closed down in 1969 when it was demolished to make way for Maidenhead's new relief road.

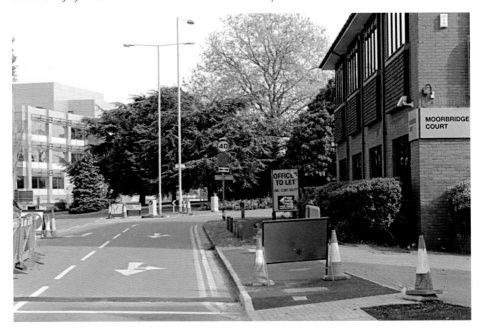

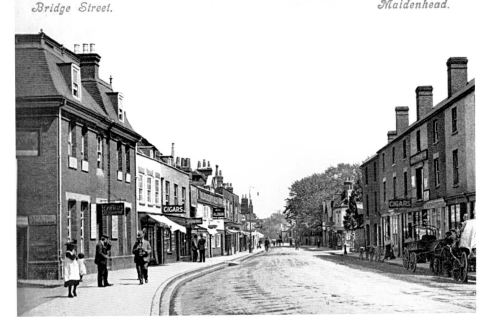

Bridge Street. *Maidenhead.*

The Model Lodging House and the Albion Public House, Bridge Street, 1905
The Maidenhead lodging house opened in 1892 for the accommodation of workmen and travellers in search of work. It was offered as an alternative to lodgings in public houses where they might otherwise be tempted by drink. The lodging house was opened by the Revd Henry Meara, vicar of St Luke's church and chaplain to the Cookham Union Workhouse, and local philanthropist, James D. M. Peace. The house closed with the improvement of social conditions in 1920, and was later used as a social club. The nearby Albion public house was opened by George Cooper in 1840 and closed in 1991.

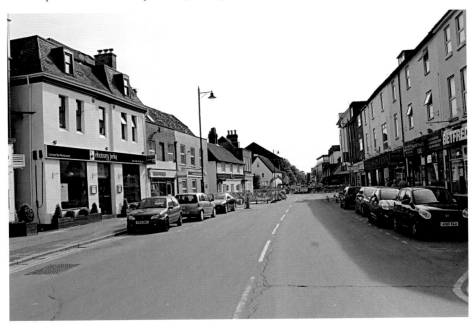

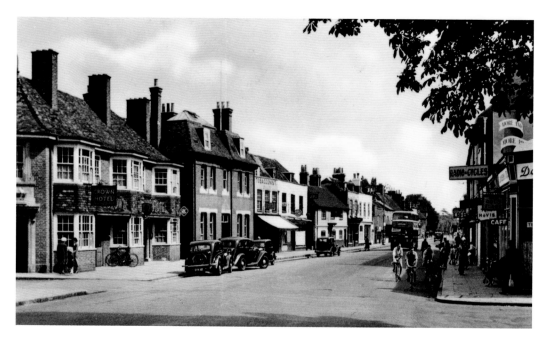

The Crown Hotel, Bridge Street, 1930

The Crown public house opened its doors in 1840. The first landlords were William Sewell and his wife, Mary. During the late Victorian period, part of the pub was used to provide lodgings for the poor. This was known as the Crown Common House. It operated in a very similar way to the adjacent Maidenhead lodging house, the only difference being that the inmates were allowed to drink. In 1927, the pub was refurbished and the common house accommodation was demolished and rebuilt. In 1928, the pub reopened as the Crown Hotel and remained until it was demolished in 2003.

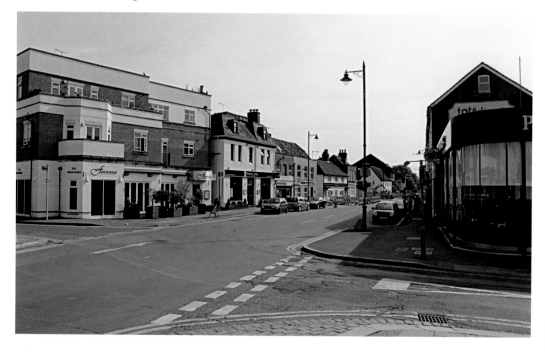

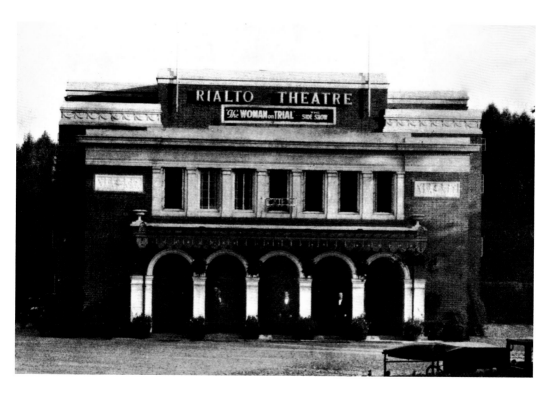

The Rialto Cinema, Bridge Avenue, 1928

The Art Deco Rialto Cinema (later the ABC Cinema) was opened by Mayor Charles Cox, on 1 November 1927 with the silent classic *Ben Hur*. The cinema was designed by specialist cinema architect, Robert Cromie, and built by the local building firm William Creed & Co. There was space to accommodate 717 people over two floors. The cinema possessed a Wurlitzer organ that rose up from the orchestra pit, and also had an indoor fountain and restaurant. The cinema closed in 1985 and was demolished shortly afterwards.

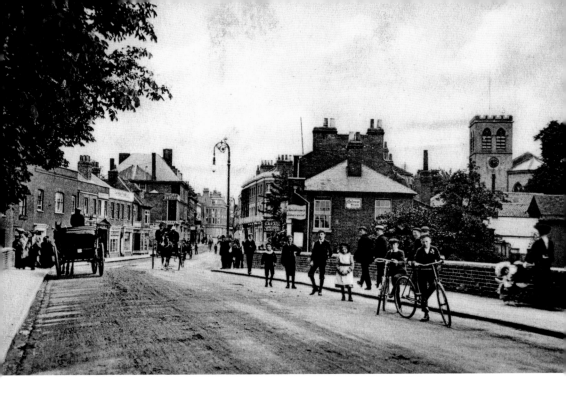

High Street from Chapel Arches, 1908

Chapel Arches marked the end of the historic medieval town. The majority of the land further east was subject to flooding from a number of small tributaries of the River Thames. Chapel Arches takes its name from a medieval chapel of ease that was erected in 1270 and dedicated to St Andrew. The chapel stood in the middle of the High Street, serving both the parishes of Cookham and Bray – the parish boundary being the centre of the High Street. The chapel was rebuilt in 1726 and, a century later, was demolished and moved to a new site set back from the High Street.

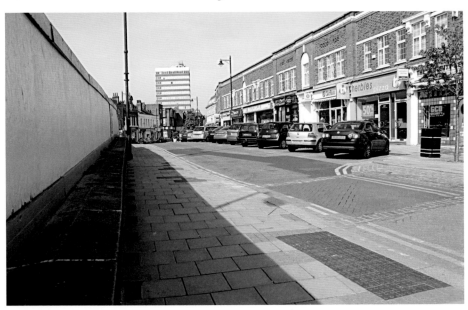

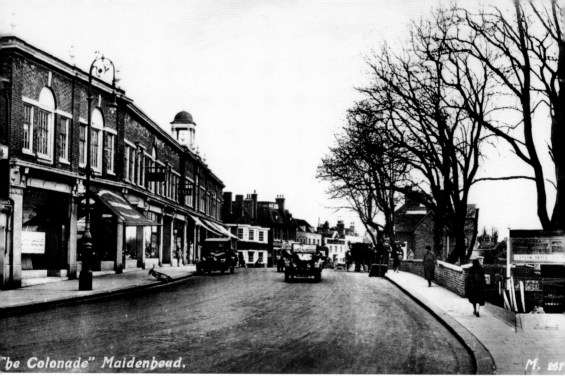

"be Colonade" Maidenhead. — M. 261

High Street Colonnade, Chapel Arches, 1935

In 1825, Chapel Arches was rebuilt in brick as its original medieval timber superstructure was starting to decay. In 1930, a parade of shops built in the style of Robert Adam, known as the High Street Colonnade, was erected adjacent to the Bear Hotel on the north side of Chapel Arches. This included the El Toucan run by the actress, Diana Dors. At the time of writing, the Colonnade is under threat of demolition as part of a new inland waterway scheme.

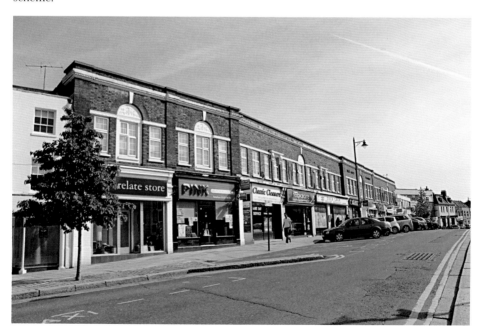

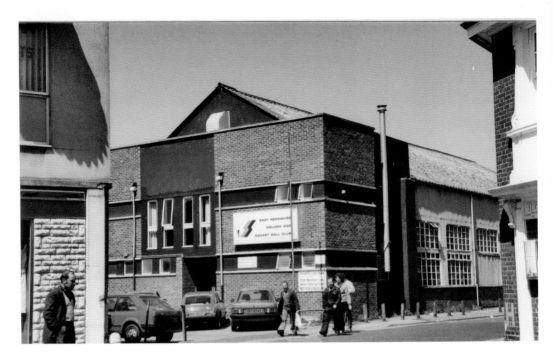

Site of the Ritz Cinema, 1968

The Ritz cinema (also know affectionately as 'the Fleapit') replaced an earlier cinema known as the Picture Theatre, which was converted from the old Maidenhead skating rink that closed in 1934. A new cinema was built adjacent to the old cinema, designed by the architect A. H. Jones. It could hold 748 people, all on one floor. This cinema, which opened on 20 January 1936, was decorated in green and black, and had black doors. It had great competition from the Rialto and Plaza cinemas during the Second World War, and eventually closed in 1943. It was then used to manufacture flooring for Wellington Bombers for the war effort and later converted into squash courts.

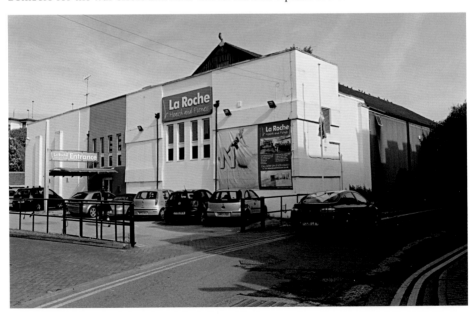

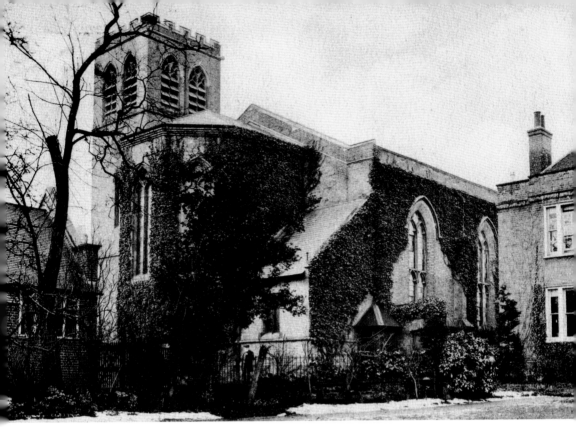

St Mary's Church, High Street, 1929
The church of St Andrew and St Mary Magdalene was moved from the centre of Maidenhead High Street to its current location. A new church designed by Charles Busby of Brighton, was constructed between 1822 and 1825. The church originally had tiered seating, arranged in a horseshoe shape around the altar. During the late Victorian and Edwardian period, 800 people regularly attended services. In 1961, the church was declared unsafe and was demolished. The current church was designed by Lord Mottistone and Paul Paget. It was built by local builder J. M. Jones Ltd, and was consecrated in 1965.

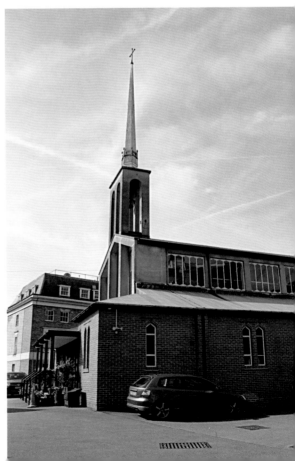

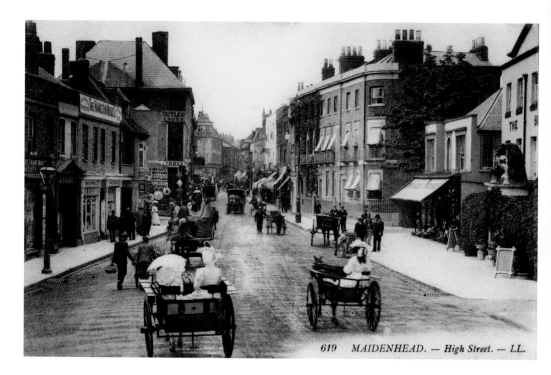

619 MAIDENHEAD. — High Street. — LL.

Lower Maidenhead High Street, 1905

A busy High Street scene focused in the area between the Bear Hotel and St Ives Road. The Medieval Bear Inn (first mentioned in 1489) stood further up on the Bray side of the High Street. The current Bear Hotel site only dates from the 1830s, and was built on the site of the medieval vicarage. The terracotta bear that guards the entrance to the building was manufactured at Pinkney's Green Brick Kilns by John Kinghorn Cooper. In the foreground can be seen Butler & Sons' Drapery at the junction with St Ives Road.

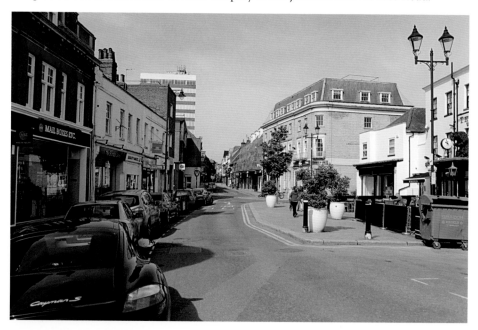

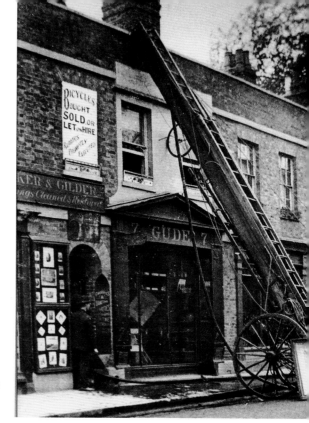

Fire at Gude's Shop, High Street, 1910
George Gude ran a successful photographic studio. Sitters included King Edward VII and Dame Nellie Melba. In April 1910, a fire broke out at the studio at No. 7 High Street. The Maidenhead Volunteer Fire Brigade was called to put out the fire. A fireman's ladder can be seen leaning against the shop front, while the owner of the adjacent picture framers looks on. The fire brigade was formed in 1866, and a purpose-built fire station, provided by the Corporation of Maidenhead, was built in Park Street in 1893.

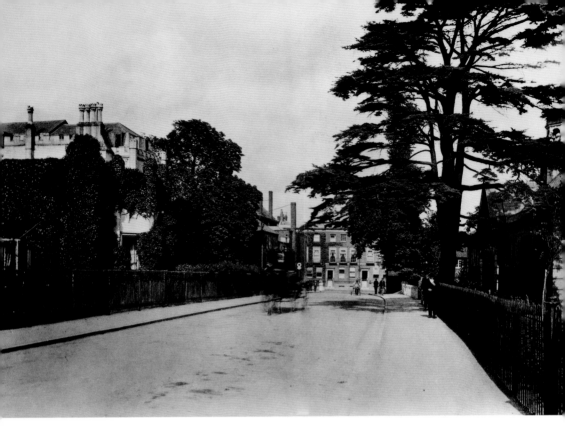

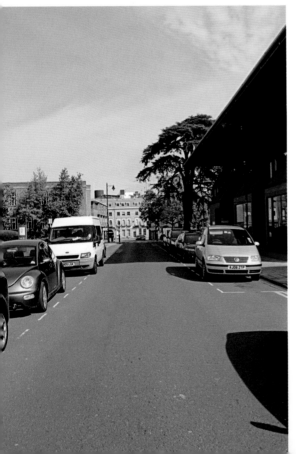

St Ives Road, 1910

In 1910, St Ives Road was dominated by two buildings – St Ives Place, on the western side of the street, and the Carnegie library on the eastern side. St Ives Road recalls the site of the medieval Manor of Ive, which was an estate belonging to the monastery of Bisham. The name 'Ive' derives from the Ive family, who held the manor in the thirteenth century. The prefix of 'Saint' was added William Wilberforce, the son of the celebrated anti-slavery campaigner, when he took up residence at Ives Place. Wilberforce founded Maidenhead's first Roman Catholic school and chapel.

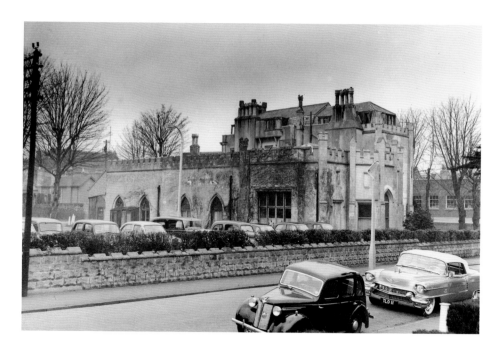

St Ives Place, St Ives Road, *c.* 1955

St Ives Place was an eighteenth-century mansion that was built on the site of an earlier manor house. The Manor of Ives was given to Anne of Cleves after the Dissolution by King Henry VIII. The manor later passed to two prominent Maidenhead families, the Whitfields and the Powneys. During the first decade of the twentieth century, the mansion was converted into a hotel known as the Hotel St Ives. The hotel was compulsorily purchased by the Borough of Maidenhead in 1939, and was demolished in the early 1960s. The current town hall opened on its site in 1962.

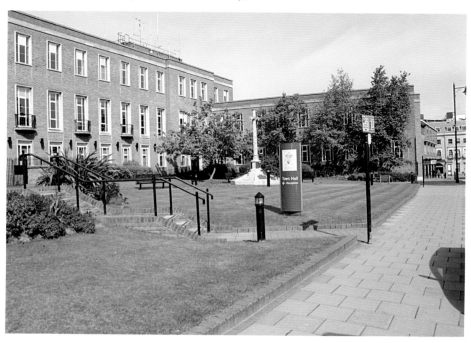

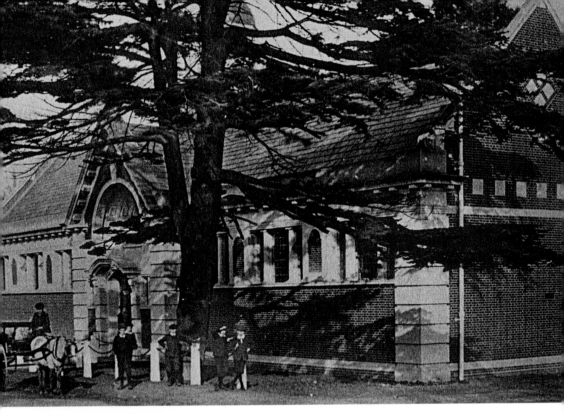

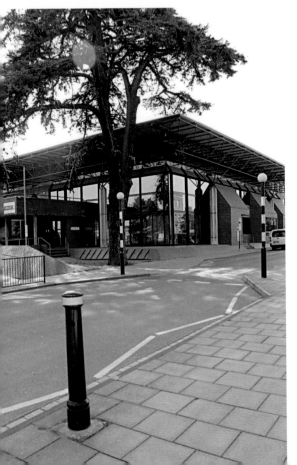

**Maidenhead Public Library,
St Ives Road, 1905**
The idea of a free public library was first
suggested in 1891, but it was not until 1902
that the idea came into fruition. This was
due largely to the philanthropist Andrew
Carnegie, who promised to give £5,000 to
build a free public library on the proviso
that the corporation would provide a site.
The library opened on 27 October 1904
on land purchased from brewer, William
Nicholson. It provided a service to the
town for almost seventy years before
being rebuilt in 1972. The new library
was designed by the architectural firm,
Ahrends Burton & Koralek.

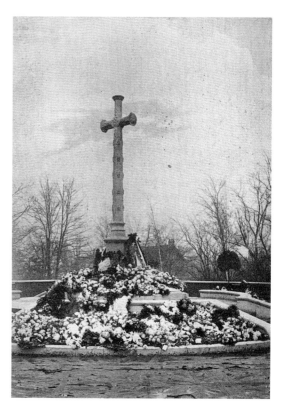

Maidenhead War Memorial Cross, St Ives Road After its Unveiling, 1920

The Maidenhead war memorial, originally sited outside the old Carnegie public library, was unveiled by Lord Desborough on 4 December 1920. Originally designed to commemorate the men of Maidenhead who fell in the First World War, further names were added after the Second World War, and also after more recent conflicts. The war memorial was moved to its current site outside the town hall in August 1970.

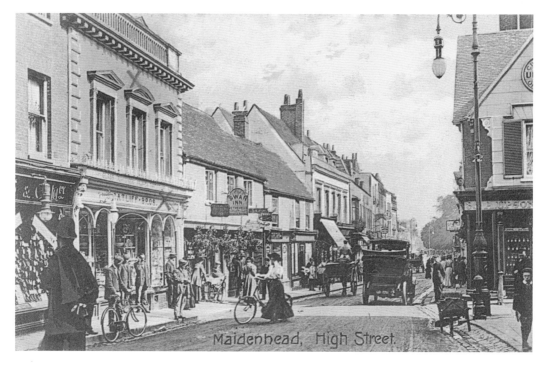

The Swan Inn and Catliff Bros, High Street, 1914

The Swan Inn was built during the fifteenth century. The first reference to the Swan can be found in a trade directory of 1796, when the inn was being run by Martha Kirkpatrick. In the late 1920s, the old medieval inn was replaced by a new building and was known as the Swan Hotel. The Swan Hotel closed down in 1967. Catliff Bros' china shop opened in 1911. The china shop was run by Charles Catliff while his brother, Francis, ran a stationary shop in Queen Street. Catliff Bros closed down in 1942 during the war.

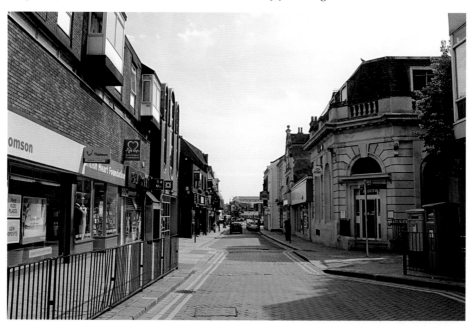

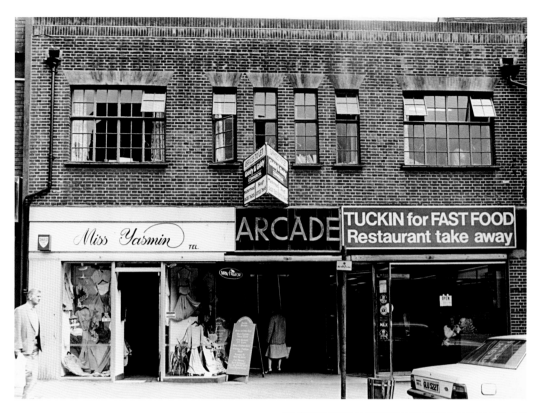

High Street Arcade, 1980

The High Street Arcade was built in 1938
by demolishing two eighteenth-century
buildings adjacent to the Swan Hotel. The
Arcade was an indoor market that sold fresh
produce such as fish and meat. Portsmouth's
the fishmongers was established in 1938
when the arcade first opened, and were
still there at its closure in 1987; three
generations of the family later. The arcade
led to an outdoor fruit and vegetable
market on Providence Place. The Arcade
was demolished in 1988, and the site is now
occupied by the Royal Bank of Scotland.

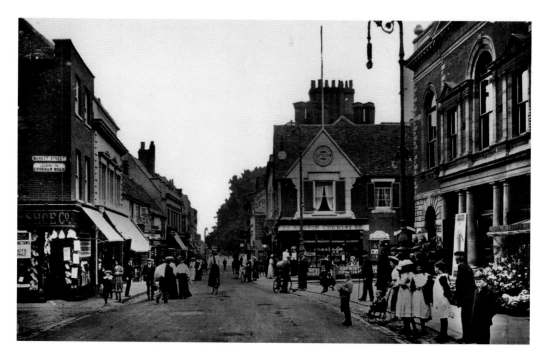

Upson's Chemist, High Street, 1917

A chemists had existed at the corner of High Street and Park Street since the late 1820s. In 1840, John Higgs went into partnership with his brother-in-law, Robert Walker. They remained in partnership until 1852 when it was dissolved. The shop was then run by Robert Walker and was taken over by his son, John Wesley Walker, in 1886. John W. Walker ran the chemist until 1895. The business was run by Arthur Upson between 1885 and 1922. By 1924, the building had become the London Joint City & Midland Bank Ltd, and still remains a bank to this day.

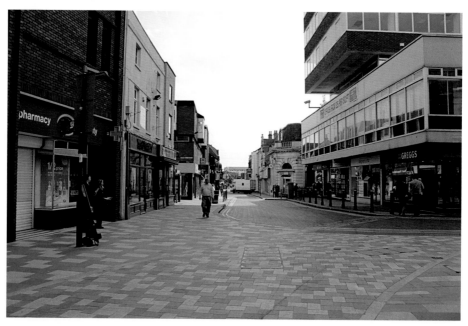

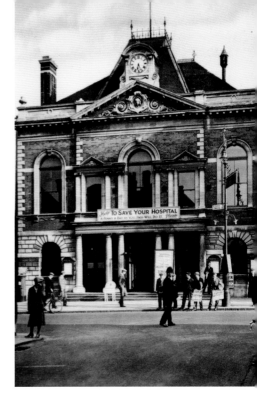

The Guildhall, High Street *c.* 1950s
Maidenhead's original medieval guildhall, built around 1430, stood in the middle of the High Street at its juncture with Market Street, and was known as the Copped Hall. The guildhall, illustrated in the image, was erected in 1777 by Thomas Emblin and John Cooper from designs by Theodosius Keene. The building included a council chamber, assembly room and a corn exchange, below. It also consisted of a beer house, known as the Fighting Cocks Inn, and a lockup. In 1878, the main assembly hall was doubled in size, and the beer house removed. The guildhall was demolished in February 1963.

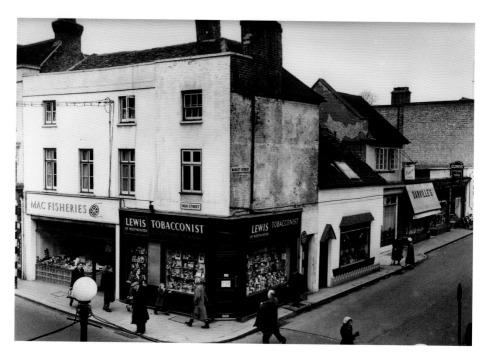

Corner of High Street and Market Street, 1955

Mac Fisheries, situated close to the junction of the High Street with Market Street, was a familiar landmark in Maidenhead. The shop was part of a chain of over 400 fish shops opened by Lever Brothers, around 1923. Mac Fisheries served Maidonians for half a century before closing its doors in 1978. On the corner of Market Street was Lewis of Westminster, a tobacconist that boasted some 350 branches across England. In Market Street was Darvilles, which opened in Maidenhead after the war. It was part of a chain of grocery shops, originally founded in Windsor by James Darville during the 1870s.

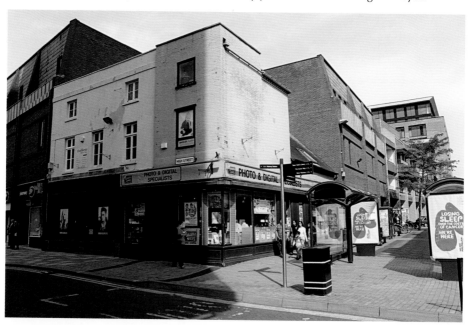

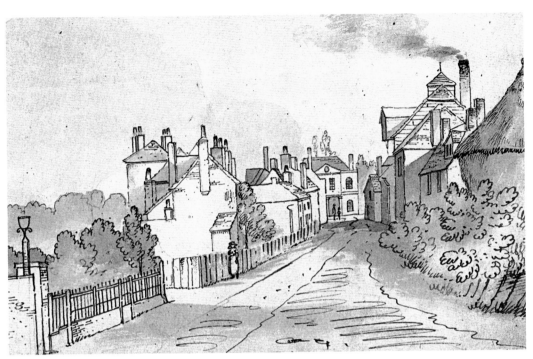

Drawing of Market Street, 1826

Market Street was originally known as Shepherd's Lane, and during the early nineteenth century it was known as North Street. By 1860, it had become known by its current name of Market Street. This street was the main thoroughfare, which ran from the village of Cookham to the marketplace, that was centred on the old Guildhall in the High Street. In 1826, the eastern side of Market Street was mostly residential. The opposite side of the road was dominated by Langton's Brewery, founded by the Langton family in the 1640s. Note the hayrick at the top end of the street.

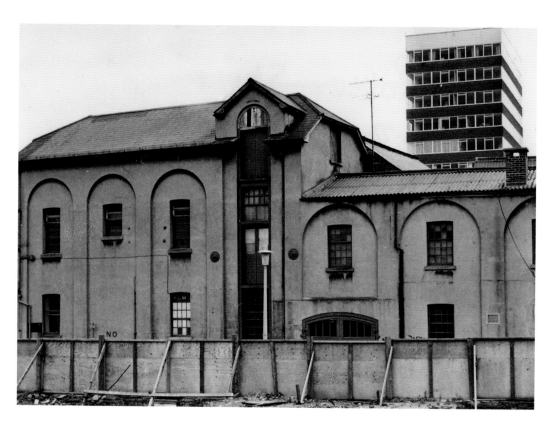

Langton's Brewery from West Street, 1979
The late eighteenth-century Langton's Brewery was replaced by a new brewery building in 1852. The maltings for the brewery were situated in nearby East Street. The 1860s and '70s saw a number of shops and businesses open on Market Street. In 1902, Langton's Brewery was sold to Nicholson's Brewer, in Maidenhead High Street. The brewery building remained the property of Nicholson's Brewery until it ceased trading in 1960.

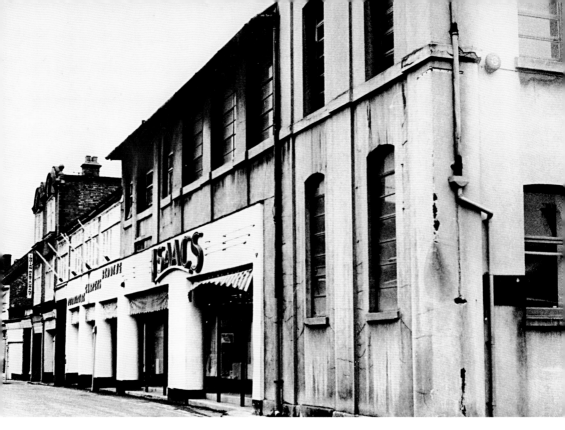

**Isaac's Furniture Store,
Market Street, 1975**
During the 1960s, the old Langton's
Brewery building was converted into Isaac's
Furniture Store. The furniture business,
founded by Nathaniel Isaacs in the 1860s,
started as a pawnbrokers in Slough High
Street. It later moved to larger premises
in Slough, and expanded by opening new
branches in Windsor and Maidenhead
in the 1950s and '60s. The old Langton's
Brewery building was demolished in 1980.
A new replacement and two other shops
were built on its site. Isaac's closed down
in 1987.

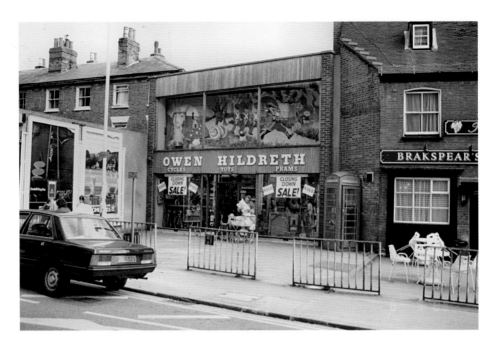

Owen Hildreth's Toy Shop, Market Street, 1985

Owen Hildreth first started making bicycles in High Wycombe in the 1890s. He moved to Maidenhead in 1900, and was employed as a foreman at Thomas Timberlake's Cycle Works in Queen Street. By 1915, he had opened a shop in Market Street and in the early 1920s, had expanded by purchasing an adjacent shop. Hildreth's was later to diversify by selling prams and toys. The old shop was demolished in 1958 and replaced with a purpose-built shop. The business was run by three generations of the Hildreth family and closed down in 1985. The building was demolished in 1987.

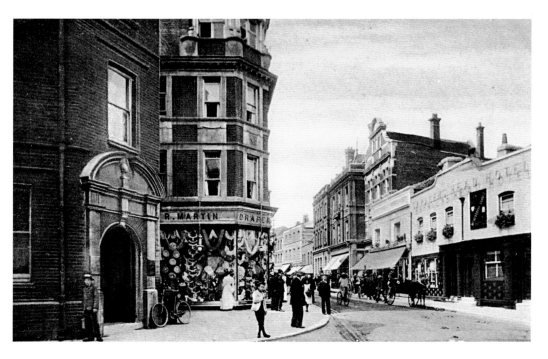

The Saracen's Head and Richard Martin, Drapers, High Street, 1910
The Saracen's Head Inn can be traced back to 1622 and later became a coaching inn. During the 1850s, a new façade was added to the building which concealed the earlier building and its roofline. The building was later converted into a shop for Marks & Spencer and, when they moved to their current location, it was taken over by Boots the chemist, which was demolished. A new Boots was built in 1976. Richard Martin's drapery and chemist shop was directly across the street. It was founded by Bolton-born Richard and Julia Martin in 1890. It closed in 1934.

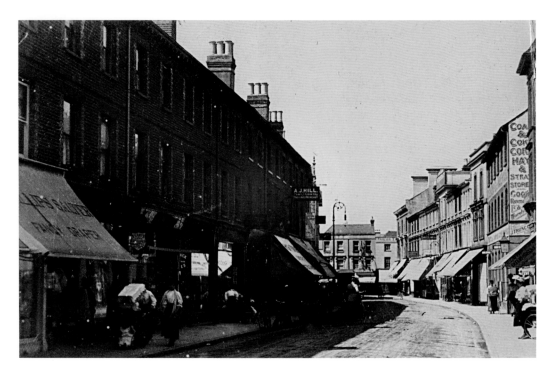

Queen Street Looking North Towards the High Street, 1917
Queen Street was originally known simply as 'New Road'. It was originally built as a residential area, but during the 1870s and '80s, was transformed into a shopping street. It was extended in the 1870s to join up with King Street. There was a complete mixture of businesses ranging from drapery shops to grocers and corn merchants to dressmakers.

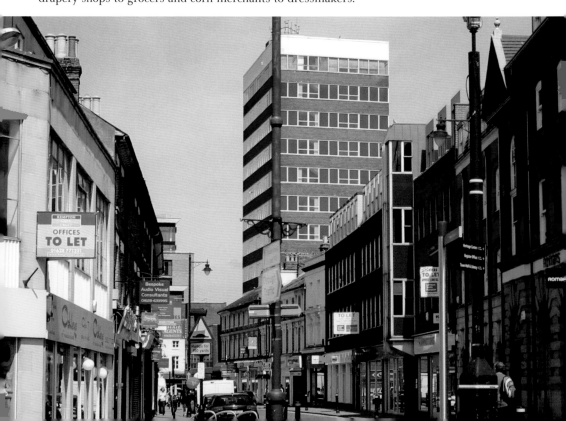

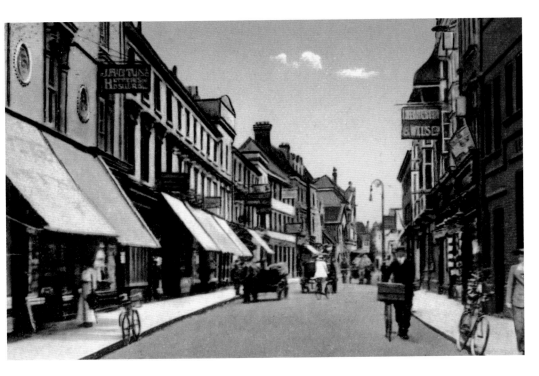

Queen Street, Viewed From the High Street, 1920
Although this view was taken in 1920, there is a distinct lack of motorised traffic. The first car to be seen on this street was in the 1890s, when a man with a red flag had to walk in front of the car. By this time, Queen Street had become Maidenhead's second shopping street and contained a similar mixture of shops and businesses.

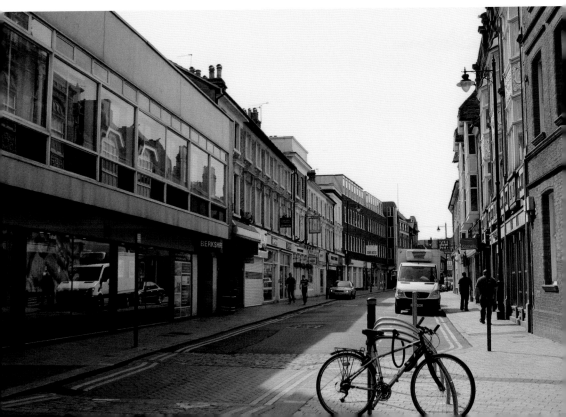

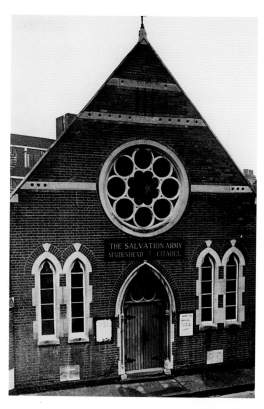

Salvation Army Citadel, Queen Street, 1974
This building was originally the Primitive Methodist's chapel. Primitive Methodism in Maidenhead started in 1844. Numbers of those practicing Primitive Methodism in the 1860s and 1870s started to grow, and a new chapel was built in Queen Street at a cost of £1,550. The chapel opened on 10 September 1882, and could seat 230 people. The chapel closed in October 1955 with the merging of the Primitive Methodists with the Wesleyan Methodists. In 1956, the chapel was taken over by the Salvation Army. The Salvation Army Citadel was demolished in 1979.

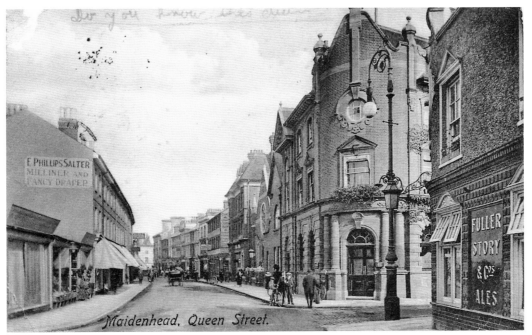

Metropolitan Bank of England & Wales, Queen Street, 1911

The Metropolitan Bank opened in Maidenhead High Street in the 1890s. It had moved to a new purpose-built building on the corner of Queen Street and Broadway by 1903. The upstairs provided accommodation for the bank manager. In 1914, the bank was taken over by the London City & Midland (later known as Midland) Bank. By 1924, the bank had moved into the old Upson's Chemist's shop on the corner of Park Street and High Street. The Queen Street bank became known as Old Bank House and was converted into a new shop for Salter's the Drapers (*seen above*).

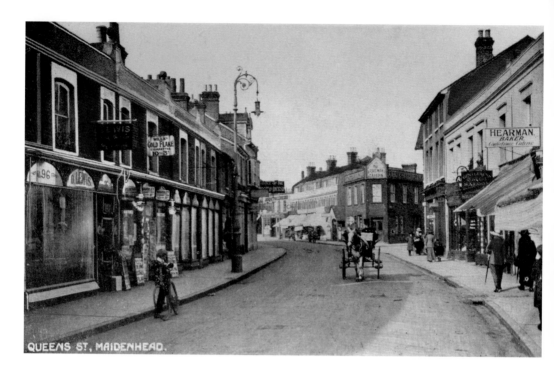

Railway Tavern, Queen Street, 1910

During the late 1860s and early 1870s, Queen Street was extended to join up with King Street. The buildings shown in the foreground of this photograph were part of the extended street. The present Maidenhead railway station was built on King Street in 1871, and later that year, the Railway Tavern opened on the junction of Queen Street and York Road. The pub was renamed The Jack of Both Sides in the 1950s and, in 2004, was transformed into The Honeypot, a gentleman's club.

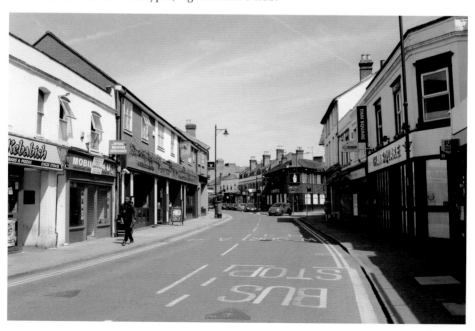

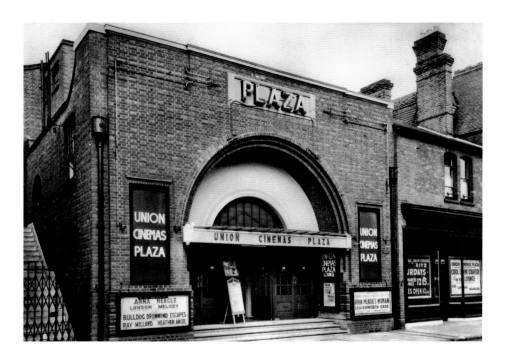

Plaza Cinema, Queen Street, 1937

The Plaza Cinema was originally known as the Picture Palace, a 500-seat cinema that opened in 1913. In 1928, it was partially demolished to build the new Plaza Cinema. The new cinema was built in brick and had a large arch over the entrance. It opened on 3 September 1928. The Plaza Cinema was taken over by the Union Cinemas chain around 1930. They were later taken over by the Associated British Cinemas (ABC) chain in October 1937. The cinema closed in October 1962, and was converted into a bingo club. In 1985, the bingo hall was converted into a nightclub, which it remains to this day.

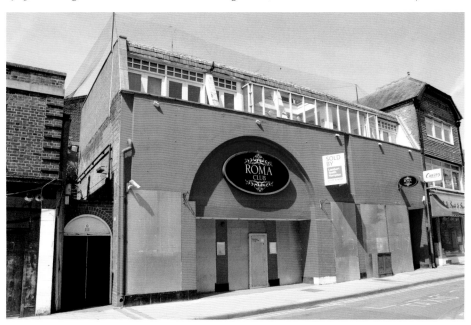

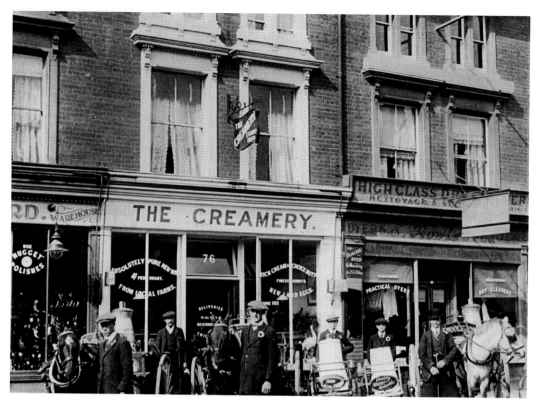

The Creamery, Queen Street, 1920

There were two dairies on Queen Street: Britton's Dairy at the High Street end of Queen Street, and The Creamery further along the road towards King Street.
The Creamery was founded in 1850 and continued until the mid-1960s. The milk came from farms surrounding the town. Milk was delivered in churns to homes in Maidenhead twice a day by horse-drawn and hand-pulled milk carts. Milk in the 1920s cost 4 d a quart. The dairy also sold freshly churned butter and eggs. The building is an empty shop today.

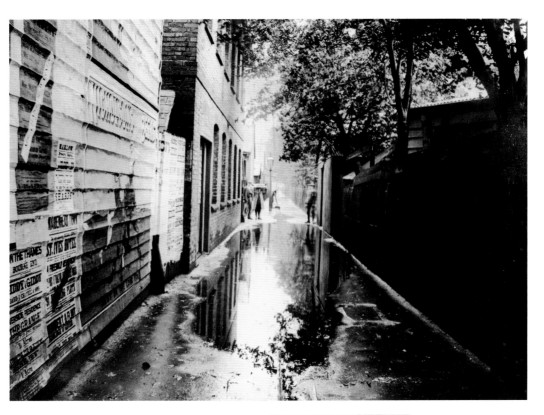

Cullern's Passage, 1905

Cullern's Passage runs behind the Queen Street shops between King Street and Broadway. The passage was named after Thomas Cullern, who was Mayor of Maidenhead in 1793. It marks out a former boundary of land that was owned by Cullern in the late eighteenth century. A poster can be seen on an old weatherboarded building advertising Nicholsons Brewery. The passage is about to be obliterated to make way for a new shopping centre to be known as King's Triangle.

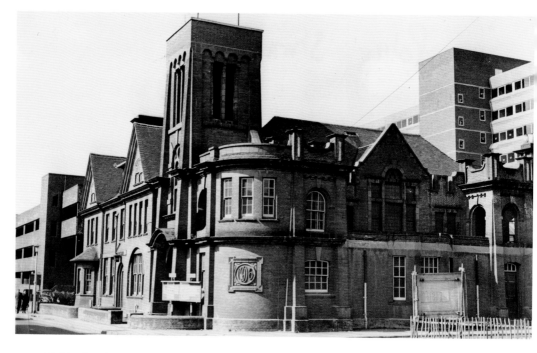

Maidenhead County Police Station, Broadway, 1979

Maidenhead formed its own police constabulary in 1836. The constabulary consisted of a sergeant and four constables, and was based in Park Street. In 1856, the Maidenhead police constabulary merged with the Berkshire constabulary and a new police station was built in Broadway. This was replaced by a brand new police station and court building in 1906. This police station was designed by John B. Clancy of Reading, the Berkshire county surveyor. In 1980, a new police station opened in Bridge Road, and the Broadway station closed. The station was demolished and now has offices built on its site.

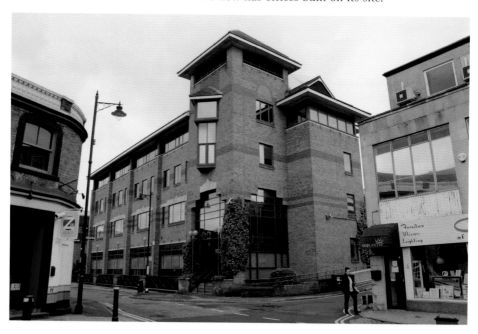

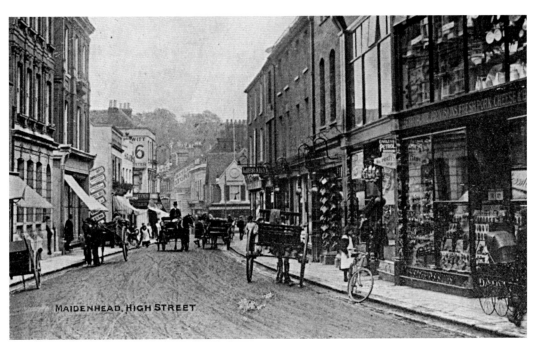

S. R. Thompson Ironmongers and Budgen & Co., Grocers, High Street, 1916

Sidney Reynolds Thompson founded his ironmongery business in 1911 (seen here with its rows of pots and pans outside the shop). He later purchased a second shop in Queen Street. Budgen's the grocer in Maidenhead High Street was the first of a large chain of grocery shops to appear across the south of England. The first store was opened by John Budgen, a former mayor of Maidenhead, in the High Street in 1872. Budgen's is believed to be one of the first supermarkets to appear in the country. Today, it has over 180 stores across the country.

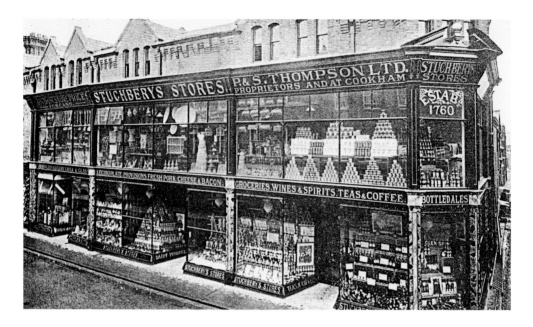

Stuchbery's Stores, High Street, 1885

Stuchbery's stores can be regarded as Maidenhead's first and only department store. In 1760, James Stuchbery opened a shop at the bottom of Castle Hill near the Sun coaching inn. The business expanded in 1874, when Thomas Stuchbery went into partnership with the Thompson family of Wargrave. It moved to newly built premises further down the High Street. At its height, there were fifteen departments within the shop to cater for the needs of a thoroughly modern Victorian household. The firm lasted until the 1950s. The shop is currently occupied by McDonald's. Sadly, Maidenhead is lacking a department store today.

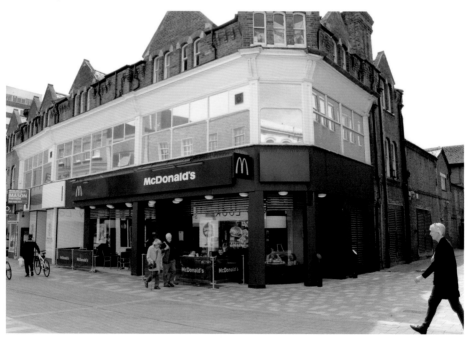

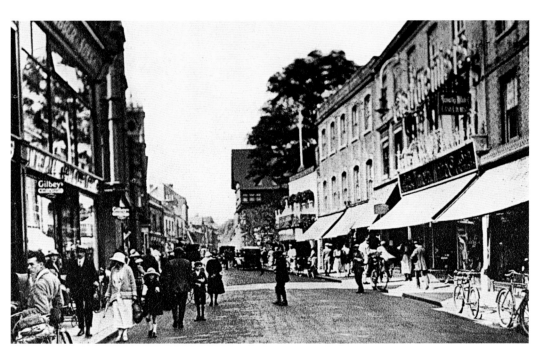

Timothy Whites, High Street, 1929

Opposite Stunchbery's was the newly opened Timothy Whites, with its large illuminated sign advertising their cash chemists business. As a firm, Timothy Whites Ltd was founded in 1904. However, the Maidenhead High Street branch opened in 1928. Timothy Whites sold household good as well as pharmaceuticals. In 1968, the firm was taken over by Boots, and as a result, Timothy Whites then sold only household goods, while Boots sold pharmaceuticals. the Timothy Whites name disappeared from the High Street in 1985.

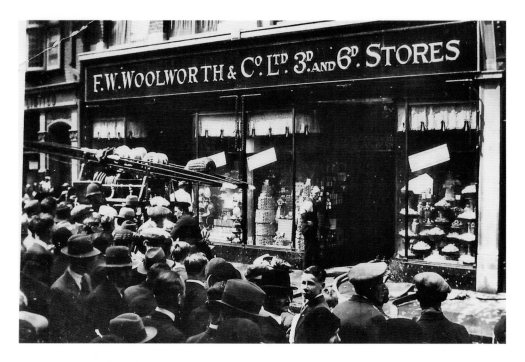

Fire at Woolworths, High Street, 1932

Woolworths was built on the site of an ancient estate and house known as Monkendons. This estate can be traced back to 1455, when it belonged to John Munkendon. The ancient house was replaced with a new building in the early nineteenth century. During the 1860s, Dr Samuel Plumbe opened a surgery with his partner, Dr Montgomery. It remained a doctor's surgery until the early 1920s. Woolworths opened in Maidenhead in 1925, and is pictured here in 1932 during a fire. The shop was modernised in 1956, and a new shop front added in 1987. Woolworths closed in January 2009.

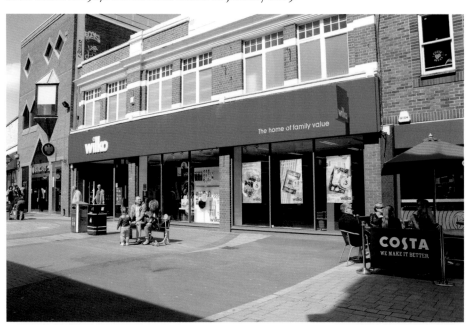

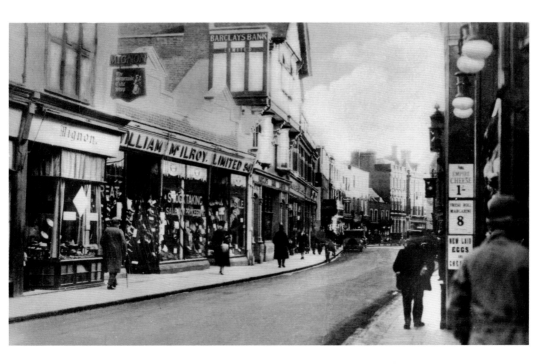

William McIlroy & Barclays Bank, High Street, 1930

William McIlroy originally came from County Londonderry in Ireland and opened his first drapers shop in West Street, Reading, in the late 1870s. By 1887, he had opened a second shop on Maidenhead High Street. The business later expanded into a chain of draper's shops and outfitters across Berkshire, Buckinghamshire and south-east England. Barclays Bank was opened shortly after the First World War, and replaced with a new bank building in the late 1920s, with its familiar mock timber-framed gable end and Oriel type windows on the upper floor. It was demolished in 1963, and the current building was erected on its site.

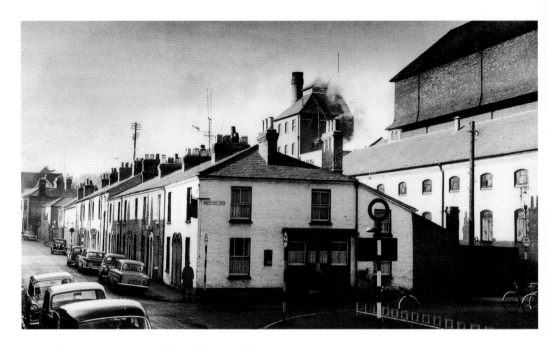

Nicholsons Brewery Viewed from Moffatt Street, 1950

The landscape shown in this picture has now been completely obliterated with the demolition of Nicholsons Brewery and the subsequent redevelopment of the site into the Nicholson's Walk shopping precinct. Behind Moffatt Street can be seen Nicholson's Brewery, founded by Robert Nicholson in 1820. The brewery started to expand from the mid-nineteenth century onwards by buying out a number of Maidenhead breweries. In 1862, the brewery employed fourteen men and, by 1935, it had risen to 150 men. In 1956, it was purchased by Courage's and, within two years, it had ceased brewing and was demolished in 1962.

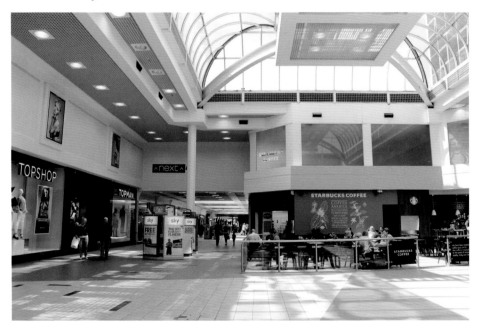

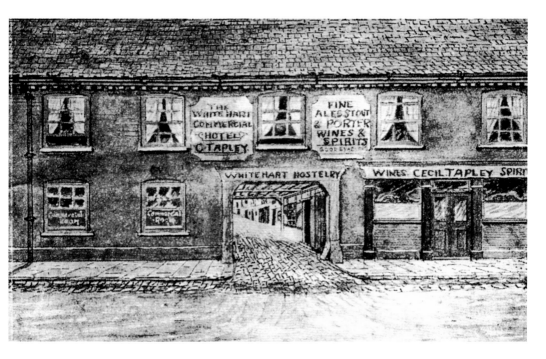

Entrance to Nicholson's Walk, High Street, 1977
Originally, this entrance to the Nicholson's Walk was the combined entrance to the stables of the White Hart Inn, and later, to Nicholson's Brewery and its offices. The White Hart Inn fronted onto Maidenhead High Street and had stabling behind for over fifty horses and twenty coaches. In 1903, the White Hart was taken over by Nicholson's Brewery. Part of the old inn was taken down to make offices for the brewery. The Inn had been on the same site from at least 1796, until it was demolished in 1962 and redeveloped as part of the precinct in 1963.

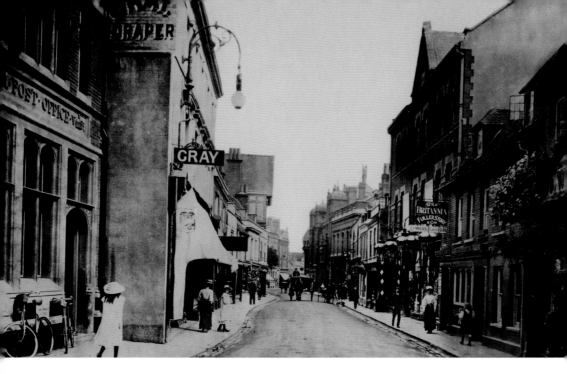

Britannia Beer House and Maidenhead Post Office, High Street, 1905

The Britannia Beer House was converted from Charles Cleare's stationary shop and post office during the late 1870s. It remained as a public house for over thirty years. By coincidence, a new building society known as the Britannia Building Society moved into the same building as the beer house in 2002. In September 1894, a new post office opened on Maidenhead High Street. This was designed by the architect Henry Tanner, who designed a large number of post offices across the country. The post office was extended in 1923. Charles Cleare was the first postmaster of the new post office.

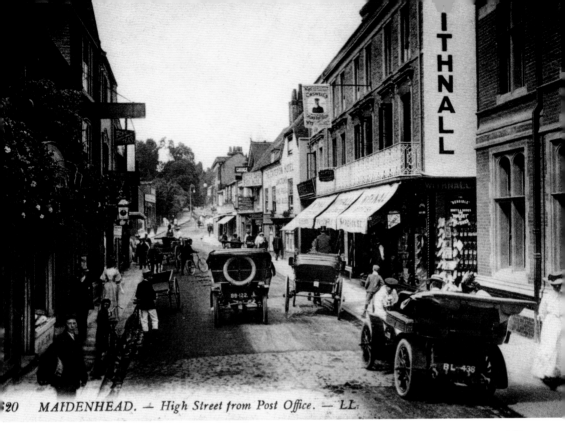

20 MAIDENHEAD. — *High Street from Post Office.* — LL.

William Withnall, Hosier & Boot Dealer, High Street, 1903

Early motorcars and wagons are seen passing Maidenhead post office and Withnall's hosiery and boot shop. The shop was founded by William Withnall in the 1880s, and was soon to expand into two adjacent shops. One of the shops was later demolished to make way for the new post office in 1892. William Withnall became mayor in 1893. Further up the road was the Criterion Hotel, which was also known as Maidenhead's public house. The shops that occupy the site today are both associated with food.

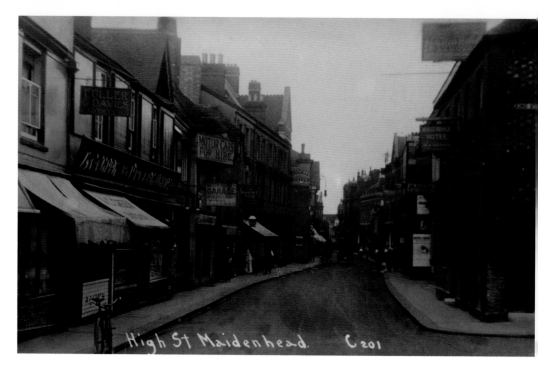

White Horse Hotel, High Street, 1915

The White Horse Hotel has stood at the junction of Maidenhead High Street and King's Street for almost 450 years. It is first mentioned in 1574 when the property was sold by Richard Wormistone of Maidenhead, innholder to Richard Winch. The inn was renamed the Brewer's Tea House in 1984, but has recently reverted back its original name, the White Horse. Opposite the White Horse was one of Maidenhead's earliest motor garages. It hired out motorcars and had a repair workshop at the rear of the property in West Street.

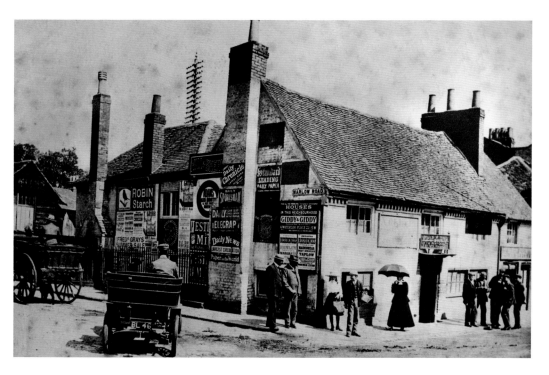

The Two Brewers Public House, High Street, 1904

The Two Brewers public house stood on the corner of Maidenhead High Street and Marlow Road. It can be dated back to at least the 1790s when it was run by landlord, John Purdy. Shortly after this photograph was taken, the Two Brewers was demolished to allow the junction between Marlow Road and the High Street to be widened. Today, this junction is under the Castle Hill Roundabout, put in as part of the Maidenhead relief road designed to take the traffic out of Maidenhead High Street during the 1970s.

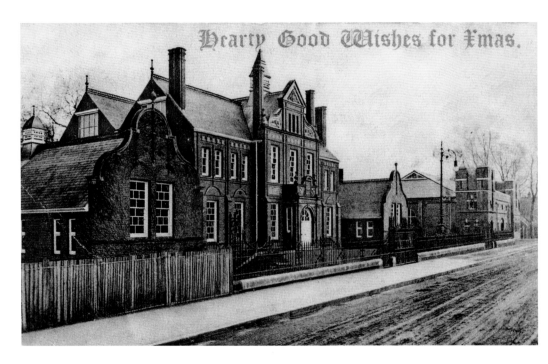

Maidenhead Technical School, 1903

The Maidenhead Technical School started as an art class which met in a school in Brock Lane and later, in a room above a warehouse in Queen Street. The Maidenhead Technical School was built on land owned by the Maidenhead Corporation and opened in 1896. The building was produced from designs by local architect E. J. Shrewsbury and cost £6,190 to erect, furnish and fit out. In 1907, the school was attended by the artist Sir Stanley Spencer. The building was later used to house the offices of the social services department and now used as a youth and community centre.

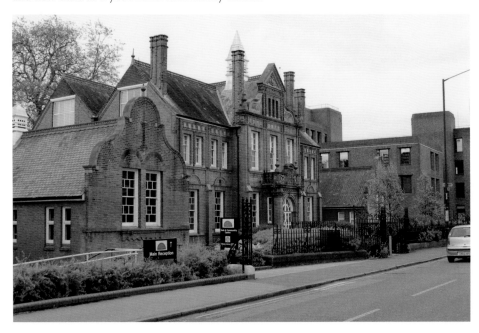

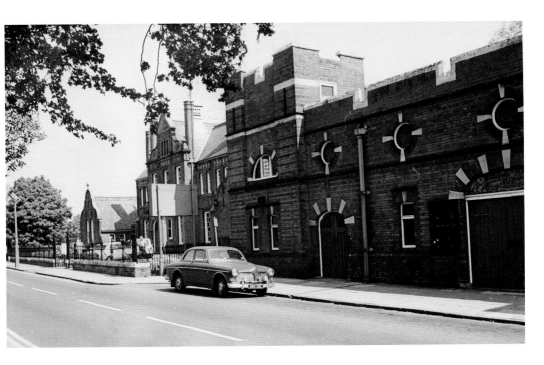

Pearce Hall, Marlow Road, 1970

The Pearce Hall was originally built as Maidenhead Drill Hall and was opened in 1903. The drill hall was built from a £3,000 legacy from James Daniel Morling Pearce. The hall was opened by his son James E. Pearce. The drill hall was used by the Maidenhead Volunteers; later the Territorial Army. The hall cost £3,200 and could accommodate 700 people. The technical institute and the drill hall were both used as hospitals during the First World War. The drill hall was demolished in 1970 and was replaced in 1972, with the headquarters building for the Commonwealth War Graves Commission.

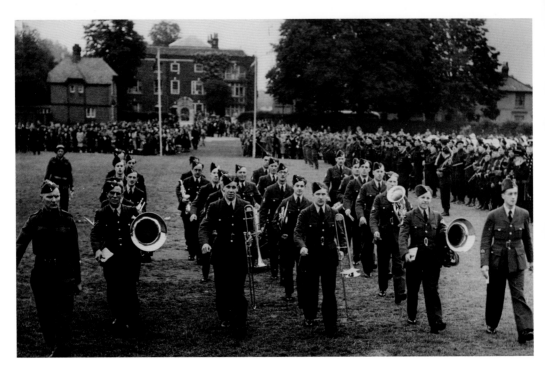

Salute the Soldier Week Parade, Kidwell's Park, 1944

Kidwell's Park was named after Sir Neville Kidwell, a former landowner in the eighteenth century. The park, like the drill hall, was given to the town by J. D. M. Pearce in July 1890. Pearce, former principal of Crawfurd College on Gringer Hill, had played an important part in the running of the town, and had been mayor five times. This photograph was captured in June 1944 as part of the 'Salute the Soldier Week celebrations'. Visible in the background is the Pearce Memorial, erected in 1900, and the former eighteenth-century home of the Langton family, brewers of Maidenhead.

Maidenhead Outdoor Swimming Pool, East Street, 1961

Maidenhead did not possess a swimming pool until 1876, when Mr William Hamblett opened a pool in Market Street. A new pool was opened in East Street in 1909. A spacious swimming pool was opened on the site of the old East Street Baths in 1937. The new swimming pool was constructed and designed by the borough surveyor, Percy Johns. The facilities consisted of a diving area, changing boxes, two ornamental cascades of water and a refreshment chalet. This swimming pool survived until the early 1980s, when it was demolished to make way for an indoor bowling alley.

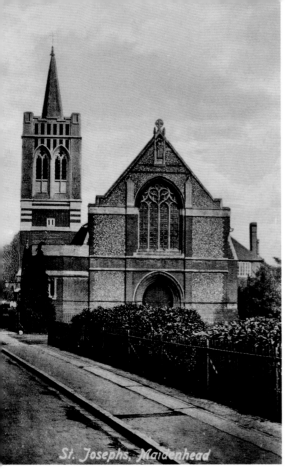

St. Josephs, Maidenhead

St Joseph's Roman Catholic Church, Cookham Road, Maidenhead, 1910

Roman Catholicism can be traced back to the 1860s in Maidenhead, when Catholics met in the old mansion of Ives Place, owned by William Wilberforce. The first chapel was converted from a High Street inn, owned by Wilberforce, known as the Bull Inn. In 1872, a chapel and schoolroom was opened on Bridge Street. Ten years later, the Catholic congregation had grown so much that a purpose-built church was designed by the architect, Leonard Stokes, which opened in 1884. The church was extended, and a new hall built, in the 1960s. The church today boasts a community of around 1,500 people.

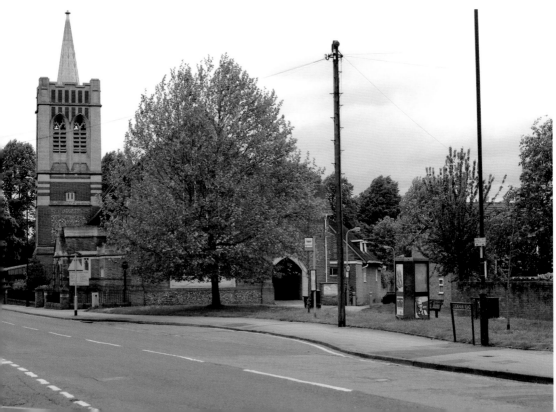

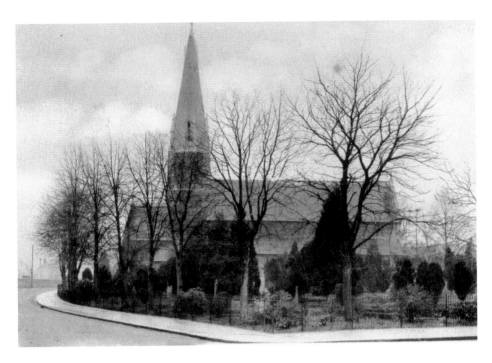

St Luke's Church, St Luke's Road, 1899

St Luke's church was designed by the architect George Row Clarke of London, and built by James Griffiths of Eldersfield, Gloucestershire. The church opened in 1866 and cost £3,500 to build. In 1869, the church was doubled in size and a tower was added to the building. In 1894, a spire of Bath stone, designed by John Oldrid Scott, was added to the tower. The old vestry was converted into a war memorial chapel in 1923. A new Vestry was built in 1932, and in 1993 this was converted into a new parish centre.

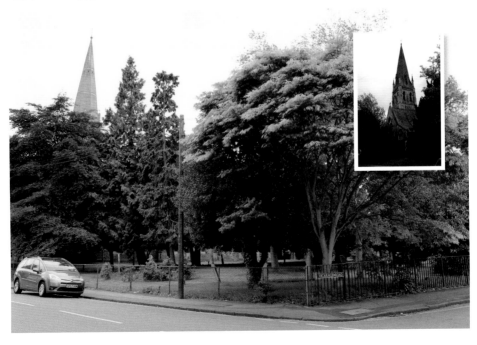

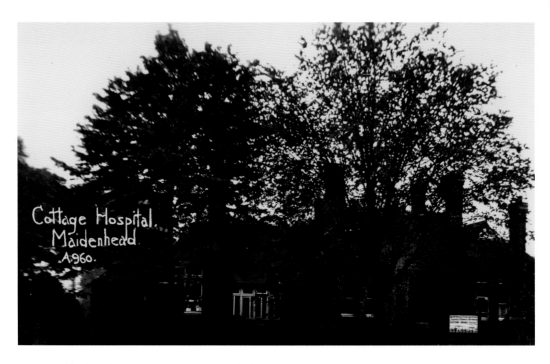

Maidenhead Cottage Hospital, St Luke's Road, 1915

The Maidenhead Cottage Hospital was built in an area known as Norfolk Park. The hospital was mostly financed by donations from the local community, and opened its doors in 1879. As numbers admitted to the hospital started to grow, the hospital was extended accordingly between 1908–28. By 1930, the hospital could accommodate over 500 patients. In 1948, with the advent of the NHS service, the hospital became known as the Maidenhead General Hospital. It closed in 1974 and its patients moved to St Mark's Hospital. The hospital closed in 1978 and the flats of Bailey Close now cover its site.

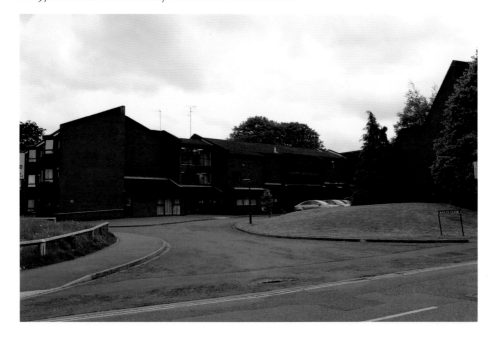

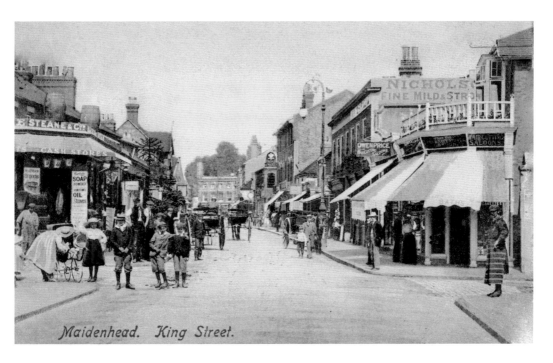

King Street Looking Towards Maidenhead High Street, 1905

King Street was originally known as the Windsor Road. Buildings on the street started to appear from the late 1860s onwards. All the buildings apart from the gable end of the Rose public house have long since vanished. The right-hand side of the image shows the buildings from the corner of Broadway to the High Street. These include the Greyhound and Prince of Wales public houses now on the site of Nicholson's Walk shopping precinct. On the opposite side of the road was Steane's the ironmongers, founded in 1884, who are still in Maidenhead, albeit on a different site.

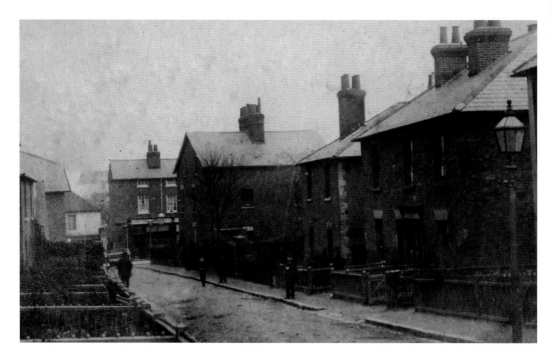

Albert Street, 1902

Albert Street is named after Prince Albert, Queen Victoria's consort and husband, and is part of a series of names connected with royalty that can be seen to form a square. These were Victoria Street, named after Queen Victoria, Princess Street and King Street. Albert Street and the other streets were built to house workers from the mid-1850s onwards. The bricks for the houses were manufactured onsite by local builder, William Woodbridge. All the houses in this photograph were demolished to make way for Frascati Way, part of the Maidenhead relief road built in the early 1970s.

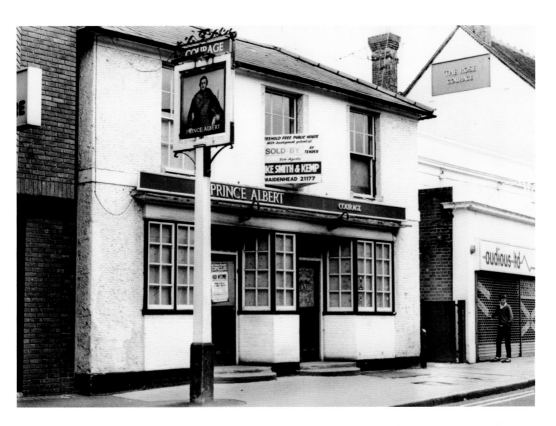

Prince Albert Public House, King Street, 1975

The Prince Albert public house stood next door to the Rose public house. It was built in the late 1850s. In 1861, it was being run by Stephen and Elizabeth Brown who had moved from Reading to Maidenhead to run the pub. The Prince Albert was demolished in 1976 to make way for new offices and a shop. These were then demolished and rebuilt in 1984.

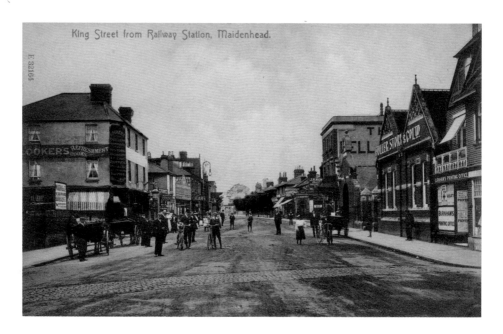

King Street from the Railway Station, 1902

Apart from the Bell Hotel (*white building on the right*), every building in this photograph has been demolished. On the eastern side of the street were the printing works run by the Burnham family, who had been printers in Maidenhead since the 1790s. Next door were the offices of Fuller Storey and Co., who ran the Bell Street Brewery at the back of the building. The Bell Hotel opened in the mid-1870s and is still running today. Across the road, on the corner of Station Approach, were Edwin Looker's refreshment rooms, which offered accommodation to travellers arriving in town by train.

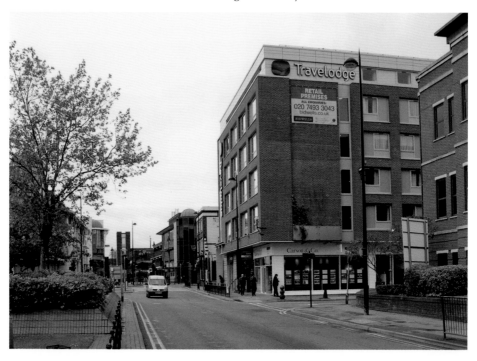

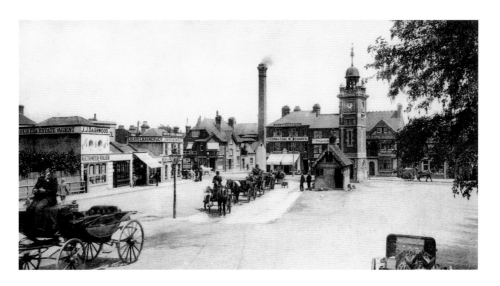

Station Approach, King Street, 1902

Station Approach today looks very different to what it looked like at the turn of the century. The only recognisable landmark being the Jubilee clock tower which, at the time the photograph was taken, would have been very new. The area around the railway station was quite industrialised with a number of corn and coal merchants, such as Leayes, Kastner & Co. The chimney and roofline of the Bell Brewery can be seen in the background. The horse-drawn taxis of 1900 have now been replaced by motorcars. Note the taxi hut in front of the clock tower.

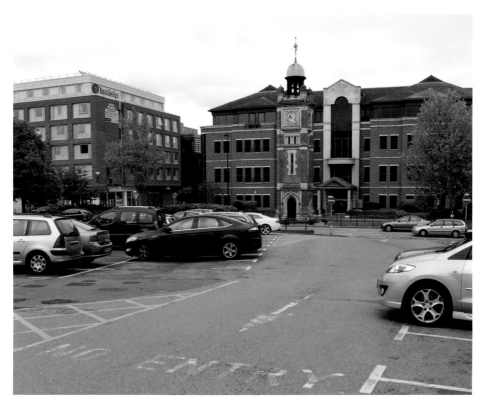

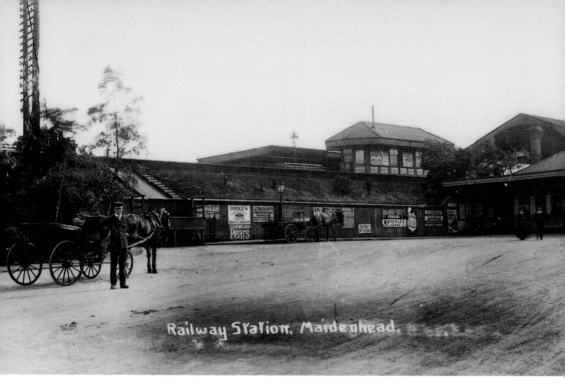

Railway Station from Station Approach, King Street, 1905

Maidenhead railway station was built in 1871. Prior to this, there was either a railway station at Taplow or the Wycombe Railway Co. station on Castle Hill. The railway station on King Street was built by local builder, William Woodbridge, and comprised of a building containing a booking office, waiting room and parcel office, with waiting rooms on each of the two platforms. The station is currently being remodelled to allow fast, direct access to the city of London and beyond as part of the Crossrail Project.

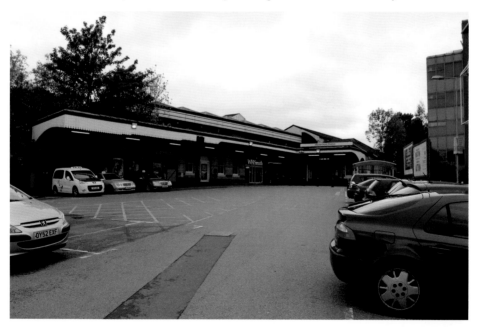

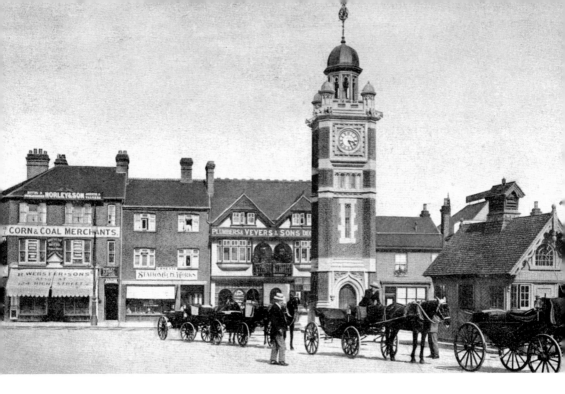

Jubilee Clock Tower from Station Approach, 1905

The Jubilee clock tower was built on the site of a memorial to local benefactor, J. D. M. Pearce on land donated by the Great Western Railway Co. The Pearce Memorial was unveiled in 1893, but moved to Kidwell's Park in 1899 when work started on the clock tower. The tower was designed by local architect Edward Shrewsbury and built by Maidenhead builders, Charles Cox & Son. The clock tower was paid for by public description and was opened by Lady Ettie Grenfell in 1900. The row of buildings behind the tower have all been demolished, along with the Bell Brewery seen extreme left.

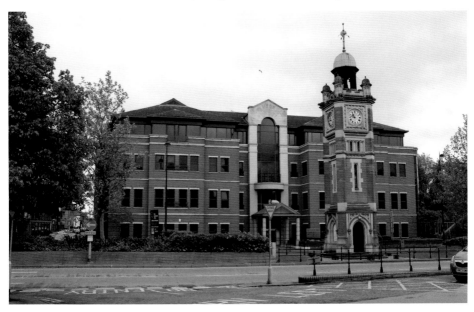

The Bell Brewery, Bell Street, 1975

In the 1840s, James Thomas Bell started up a malting business at Ray Mill, later turned into a small-scale brewery. In 1854, he opened a larger brewery known as the Bell Brewery, on the corner of Bell Street and King Street. The brewery was taken over by John and James Fuller in 1863. In 1908, the brewery acquired the Castle Brewery in Burnham and Storey's Station Brewery in Bracknell, and became known as Fuller Storey & Co. The brewery was taken over by Nicholson's in 1922, and continued to brew beer until 1959. The brewery building was demolished in 1978.

Keyes Brewery, Keyes Lane, 1975
The East Berkshire Brewery was founded
by ex-Nicholson's Brewery employee,
George Braxton. In the early 1880s, the
brewery was run by James Blunson, who
manufactured porter for the London
market. The brewery was taken over by
Alfred E. Keyes in 1887. Keyes old beer was
from an off-licence on King Street. The
brewery merged with Nicholson's Brewery
in 1895. The building was later used as
workshops for maintaining their pubs and,
when the brewery closed down, it was used
as a warehouse. The brewery is perpetuated
by the street name Keyes Place.

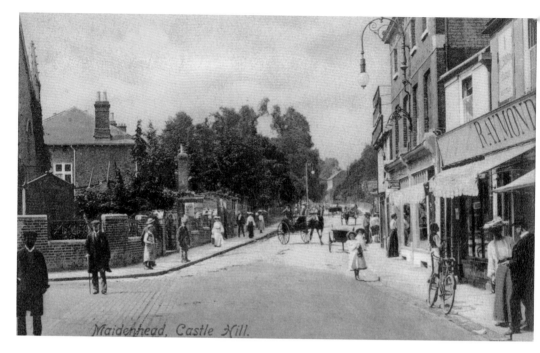

Maidenhead, Castle Hill.

High Street Junction with King Street, 1910

The side elevation of the Wesleyan church and its boundary wall can just be seen on the left. Methodism came to Maidenhead in the late 1820s. In 1858, the Methodists moved out of their small chapel to the former Countess of Huntingdon's Connection chapel at the top of the High Street, which was later enlarged in both the nineteenth and twentieth centuries. The walls surrounding the church have been removed. The shops opposite have now gone to make way for access to an underpass. A roundabout dating from the 1970s, now separates the High Street from Castle Hill.

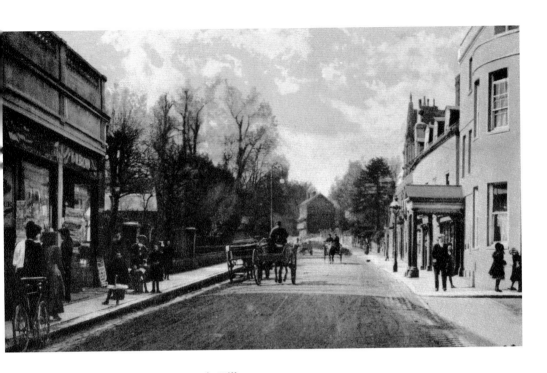

The Sun Inn and Ice House, Castle Hill, 1904
The Sun Inn (*right*) was Maidenhead's principal coaching inn, dating from the mid-seventeenth century, and had ornamental gardens on the opposite side of the road. The inn was demolished in 1971. Further up Castle Hill was the Ice House, which originally consisted of two vaulted ice wells, first used by the Sun Inn, and later by William Hamblett, a fishmonger. The wells were used to store blocks of ice for use in his shop. After his death in 1881, a house was erected over the wells by his wife. The Ice House was converted into flats in the 1980s.

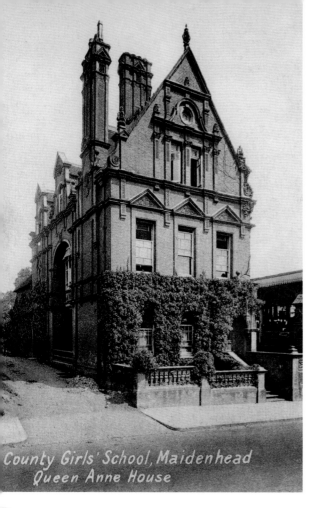

County Girls' School, Maidenhead
Queen Anne House

The County Girls' Infants School, Queen Anne House, Castle Hill, 1942 Queen Anne House, at the bottom of Castle Hill, was built in 1880. It originally housed the offices and showrooms of John Kinghorn Cooper & Sons, local brick makers and producers of terracotta tiles and finials at Pinkney's Green. He used the building to display all the things he could produce, which even included a terracotta bust of himself. The showroom closed after the war and became an annexe to the County Girls' School, on the opposite of the road from 1919 to 1959. The school was later converted into the Queen Anne Hotel, which was pulled down in 1974.

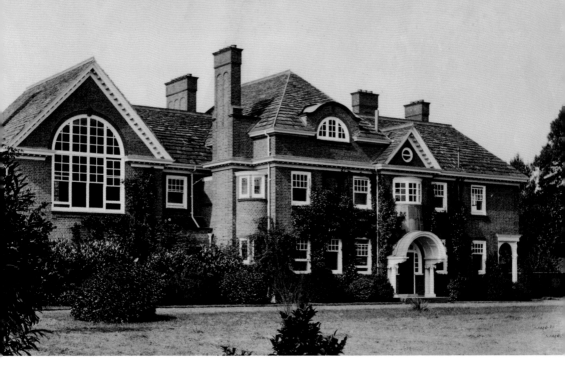

County Girls' School, Castle Hill, 1920

The County Girls' School opened in 1905 in the Technical Institute on Marlow Road, and moved into a house known as 'The Elms' on Castle Hill in 1907. By 1919, the number of children attending the school had reached 100, and an annexe opposite the school was leased until 1959. The school moved from Castle Hill to a new site on Farm Road in 1959, and became known as Maidenhead High School. In 1973, the school was renamed Newlands School. The school buildings on Castle Hill were later used as a youth centre, before being demolished in 2013.

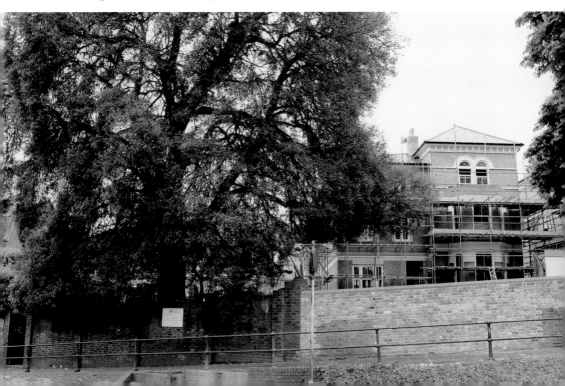

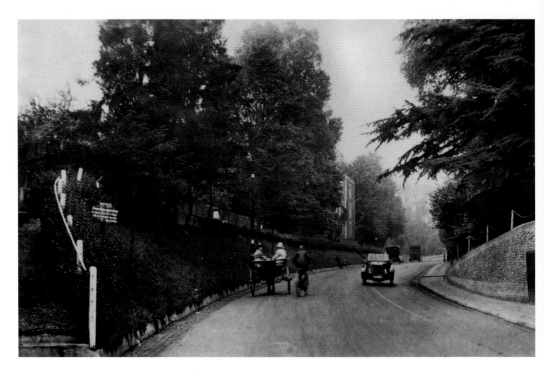

Castle Hill and Castle Hill Terrace, 1930

Castle Hill was originally known as Folly Hill, named after the Cook's Folly and later the Folly Inn, which was built in 1682. When the inn changed its name to the Windsor Castle pub in 1820, the road also changed its name to Castle Hill to reflect the new pub name. Further up the hill, a crenellated triangular tower made of vitrified bricks can be seen. This was built by Edwin Hewitt in 1880, and was the only section erected of a larger planned edifice known affectionately as 'Mr Hewitt's castle'.

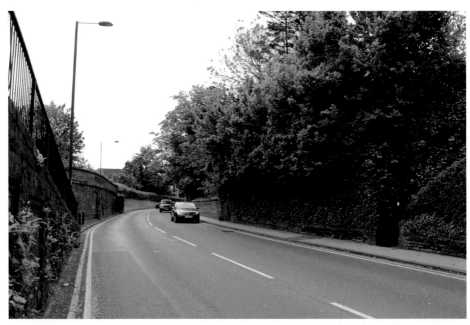

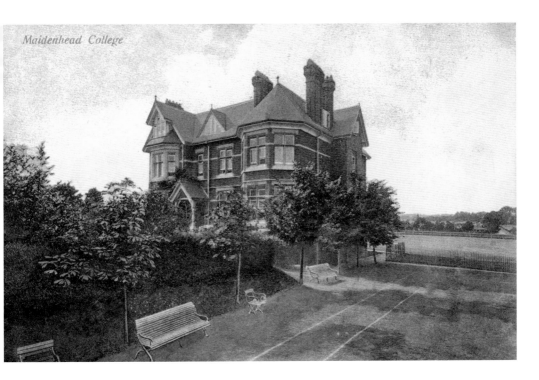

Maidenhead College

Maidenhead College, College Avenue, 1905

In 1861, Mr Andrew Millar-Inglis opened a school called Norfolk Park School on the Crescent, that ran for thirty years before moving to College Road, which he called Maidenhead College. In the 1940s, the school was taken over by The Convent of the Nativity of Our Lord, which was run by Roman Catholic nuns. In 1957, a new chapel and refectory rooms were added to the school buildings. The nuns left in 1981 and the school became independent. In 1993, the school became part of Claire's Court School, an independent school founded in 1960.

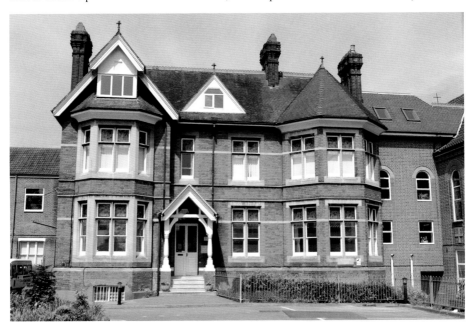

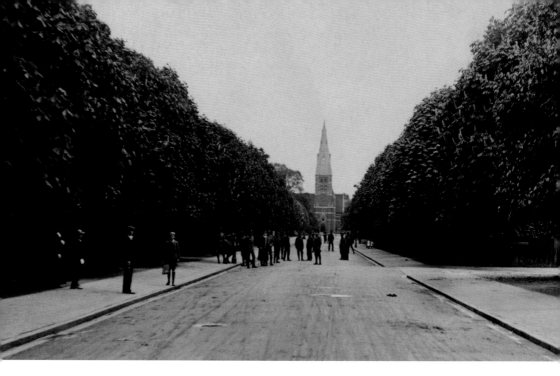

First World War Soldiers in All Saints Avenue, 1916
A group of First World War soldiers on All Saints Avenue. In the background is All Saints church, designed by G. E. Street in 1857. The land for the church was given by Charles Pascoe Grenfell and paid for by Emily and Maria Hulme, who also commissioned a house, but was never lived in. The church complex also included a vicarage, school, two clergy houses and an almshouse for six elderly people. All Saints Avenue, which was built to be aligned with the church, now has a mixture of Victorian and modern houses.

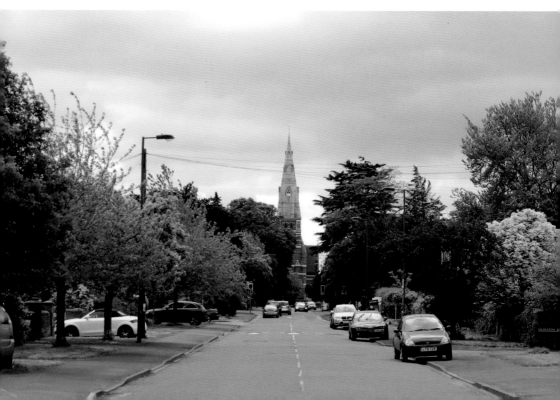

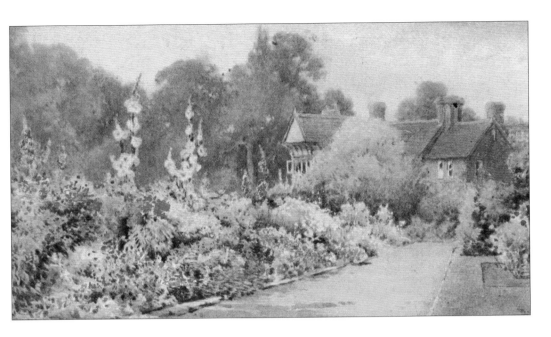

Boyn Grove House and Gardens, Courthouse Road, 1935

Boyn Grove was built around 1880 for John Cardy Wootton and his wife, Clara. It was a large mock, half-timbered house built in the neo-Elizabethan style with magnificent gardens. John Wootton founded the Boyn Hill Cricket Club in its grounds in 1890. Following his death, the estate passed to his wife and then to their unmarried daughter, Clara. In 1962, Clara Wootton left the Boyn Grove estate to be used partly as a home for the elderly and partly as an open space. Boyn Grove has been redeveloped to provide a modern home for the elderly.

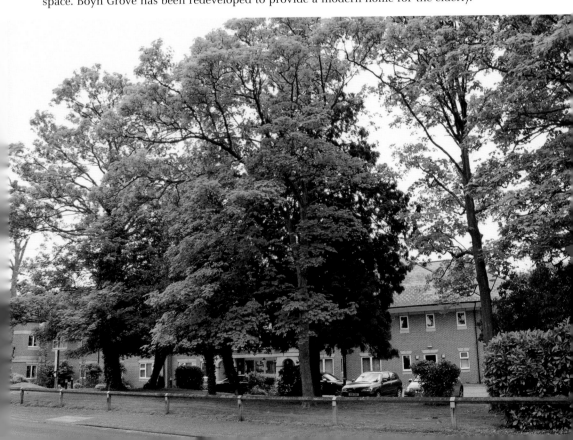

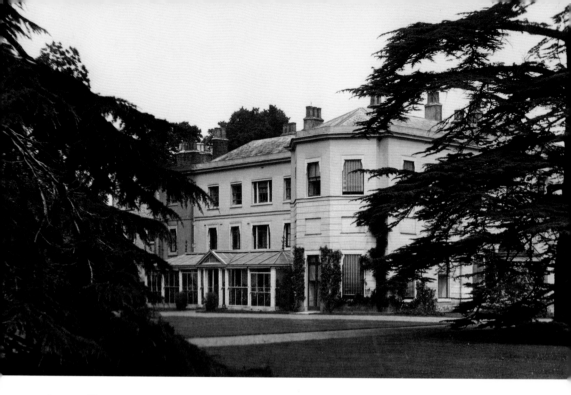

Canon Hill House, Braywick, 1920
The house was built on the site of the Domesday rectory of the manor of Bray. At this time, there was a large monastic grange that was owned by Reinbald the Priest, Dean of the Prebendary College at Cirencester. He was rector of thirty churches across England. A new house was built on its site in the seventeenth century, and was remodelled in the Adam style in 1750 and a private chapel added. The house was demolished in 1972, and a new housing estate built in 1973. The original lodge house still survives, though it is much altered.

Acknowledgements

The authors would like to thank the following:

The *Maidenhead Advertiser* for the use of photographs from their extensive archive.
Chris Atkins of Maidenhead library for his help and advice.
The Francis Frith Collection.
Clive Polden of the Cinema Theatre Association.
John Fry.
(*The organisations and individuals named above retain their copyright on the images used in this publication.*)

The lock-keepers at Boulter's lock for their invaluable assistance.

Finally, thanks to Tony Heaton for driving us around Maidenhead to take the modern-day photographs.

The selection of historic images and the text was written by Elias Kupfermann.
The modern photographs were taken by Carol Dixon-Smith.